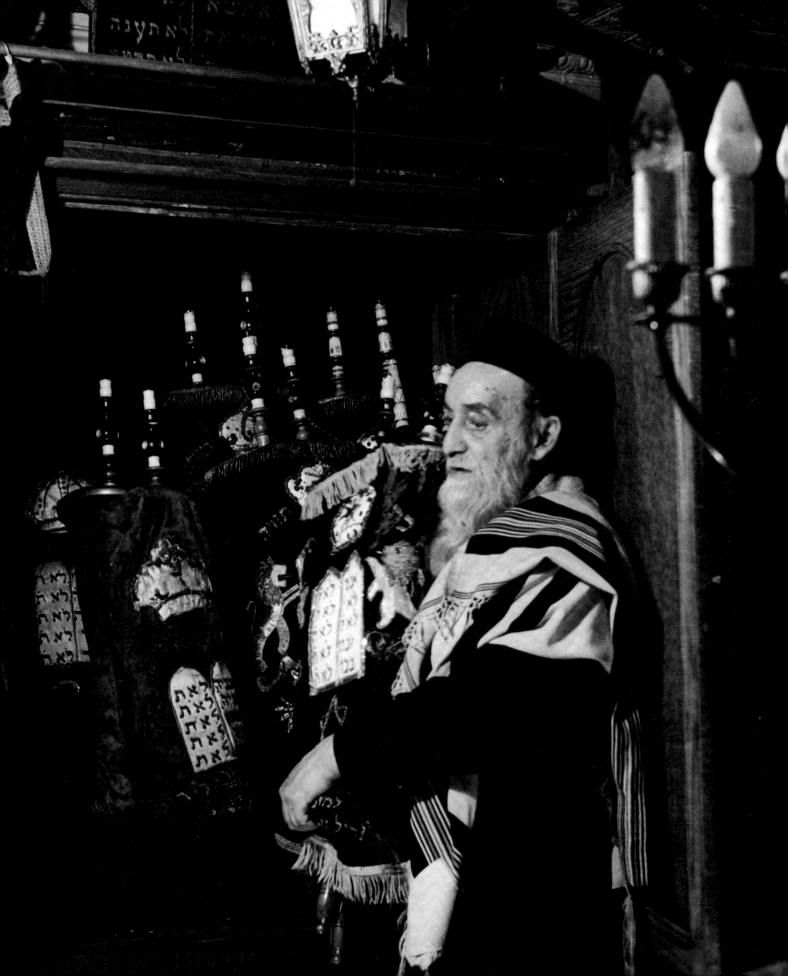

AT HOME ONLY WITH GOD

BELIEVING JEWS AND THEIR CHILDREN

PHOTOGRAPHS BY ARNOLD EAGLE
ESSAY BY ARTHUR HERTZBERG

APERTURE

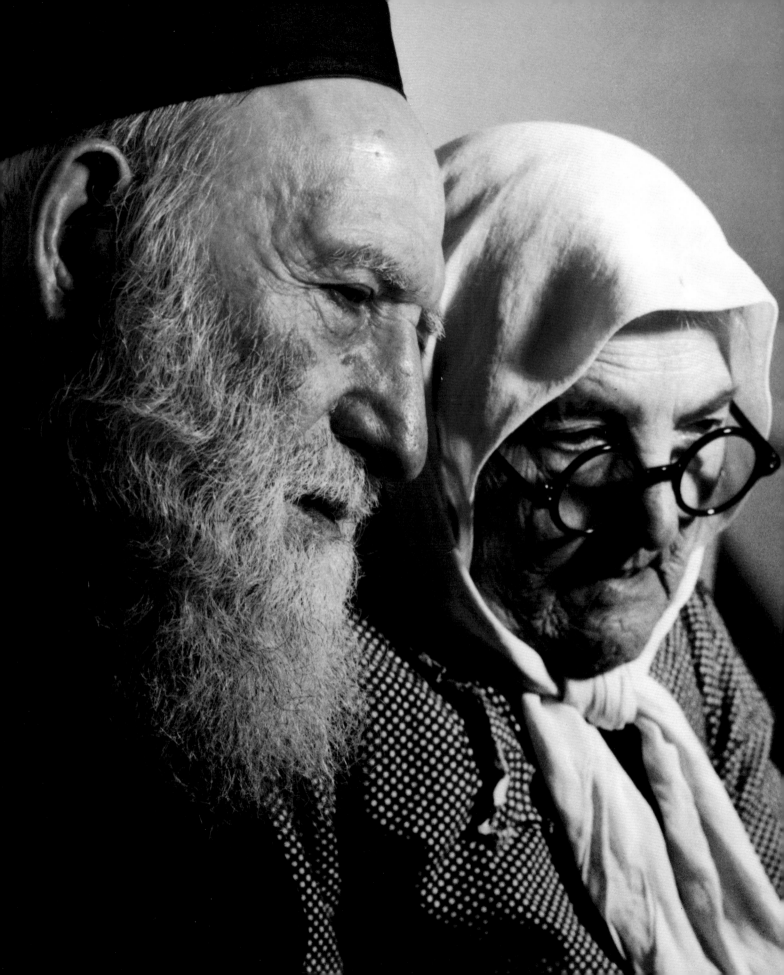

Many Jewish immigrants came to America with hope, but many others arrived resenting the new land. They called it "America gonif" (America, the thief), because it had robbed them of the world of their youth and only a few had been paid back in the coin of success. Some of the immigrants refused to change any of their ways. They kept the garb and the manner of the East European *shtetl*; they were "at home only with God." Arnold Eagle, who was in the 1930s a young documentary photographer, sensed that their way of life was disappearing, and he committed himself to preserving images of their world on the East Side. These men and women were a small minority, but even unbelievers and partial believers often found comfort in selective, warm memories of their youngest years in Europe.

On the other end of the immigrant ghetto, the socialists, anarchists, and free-thinkers were equally a minority. The reigning, conventional interpretations of immigrant history, and especially of American Jewish experience, have emphasized the rebellious spirit of the new arrivals. On the journey across the ocean they supposedly threw their European past into the sea and debarked in an American harbor as "new men." The intelligentsia and political activists among them, as Ronald Sanders maintained in *The Downtown Jews* and Irving Howe insisted in *World of Our Fathers*, were revolutionary socialists; they led the Jewish immigrants to fight for a new America. According to this account of the immigrant experience, the drama, and the tragedy, of American Jewish history after 1881 is that the children of the immigrants have abandoned the class struggle and have succeeded within the existing American capitalist system. This reading of Jewish immigrant experience is wrong. It does not take account of the fact that masses of the founders of the Jewish unions left them as quickly as possible to open candy stores in the Bronx, or sweatshops of their own. In their own lifetimes, as we know from the census of 1920, the majority of the immigrants had moved from being supposedly class-conscious laborers to becoming small businessmen or white-collar employees. There can be no doubt that most of the immigrants came not to revolutionize America but to succeed as best they could for themselves, and to launch their children.

In the era of mass migration, the language of the Jews who came was Yiddish. What they thought of the new land was expressed in the words that came naturally. Yes, America was *di goldene medina*, the golden land, but it was also *di treifene medina*, the land which subverted their

Remembering the *shtetl*, circa 1934

1

inherited values. It was *dos neye land*, the new land, but it was also the place where they encountered *di zelbe goyim*, Gentiles who harbored the same old anti-Semitism which would disappear only if society as a whole had a change of heart.

These ambivalences were expressed at their most extreme by the revolutionaries on the left, and the ultra-Orthodox believers on the right, but most of the immigrants belonged to neither camp. In the 1890s, the very years in which the revolutionaries were busy organizing the workers and creating a radical Jewish press in Yiddish, at least two-thirds of the immigrants were keeping kosher homes, and they were founding hundreds of new synagogues. To be sure, atheism had gone public in the East Side and there were even defiant dances on the holiest day of the year, the fast day of Yom Kippur, but the *Jewish Daily Forward*, the newspaper of the Jewish socialists, was counseling its most non-believing readers not to do anything on this holy day which would offend the sensibilities of the religious faithful. In his autobiography, Lincoln Steffens described the "tragic struggle," at the turn of the century, between fathers and sons over religion:

> We would pass a synagogue where a score or more boys were sitting hatless in their old clothes, smoking cigarettes on the steps outside, and their fathers, all dressed in black, with their high hats, uncut beards and temple curls, were going into the synagogue, tearing their hair and rending their garments . . . Their sons were rebels against the law of Moses; they were lost souls, lost to God, the family, and to Israel of old.

The same account was given by a writer in Hebrew, Moshe Weinberger, as early as 1887 in his *Jews and Judaism in New York*, and two decades later by Sholem Asch in a novel in Yiddish, *America, 1918*.

These tales are too negative. Before 1914 Harlem was the place of "second settlement" to which Jews moved when they were able to leave the East Side. They built large new synagogues, with some help from their children, as others were to do later in the Bronx in the 1920s. Some of the young children whom Weinberger, Steffens, and Asch deemed defiant would, as affluent adults in the 1940s and 1950s, take the lead in founding hundreds of new Conservative and Reform synagogues in the suburbs.

Most of the immigrants arrived not to replant Orthodox Judaism or to make a new world. They came with only a knapsack, and their utopia was a home with central heating and chandeliers. They knew, even

before leaving port in Europe, that they would not achieve their dreams of success, but they came *far di kinder*, for the children.

These photographs of the orthodox in New York are clearly the work of an admirer. Arnold Eagle, an immigrant himself, but from a secular Hungarian Jewish family, was impressed by the dignity of the Orthodox Jews he encountered in New York. In Arnold Eagle's images we feel both their personal resistance and the somber knowledge that their children would not be like them. Unlike the Catholics, immigrant Jews did not segregate their children in parochial schools, because the public school was the major avenue of advance as individuals into America. Even the ultra-Orthodox, those who themselves behaved as if they were still in the *shtetl*, made no attempt to raise their sons to grow beards and wear kaftans. Across the board, the young were being raised to learn the ways of the American majority. Thus children were different, and their parents expected them to be. Talking of his childhood in his memoir, *A Walker in the City*, Albert Kazin has told:

> It was not for myself alone that I was expected to shine, but for them—to redeem the constant anxiety of their existence. I was the first American child, their offering to the strange new God . . . It was in the gleeful discounting of themselves—what do we know?—with which our parents greeted every fresh victory in our savage competition for high averages, for prizes, for a few condescending words of official praise from the principal at assembly.

Until the late 1930s the majority of American Jews spoke Yiddish or strongly accented English. The census of 1940 was the first since 1840 (just before the German Jews began to arrive) in which American-born Jews were the majority. Many of this younger generation were still teenagers in 1940, because mass migration had been stopped by the discriminatory legislation in Congress only in the early 1920s. It was still possible in 1946 to fill Madison Square Garden for a celebration in honor of the 50th anniversary of the *Jewish Daily Forward*, but such an event was not even attempted only a decade later. Three Yiddish dailies were still appearing in the 1940s and a fourth, the *Morgen Freiheit*, was largely ignored because it existed as the organ in Yiddish of the Communist Party. Year by year, these newspapers were losing subscribers, as the immigrant generation died off. All the Yiddish dailies closed; even the *Jewish Daily Forward*, which has remained in existence, became a weekly. Its building, which used to dominate the East Side,

was sold to a Chinese bank. The children of the immigrants remembered enough Yiddish to laugh uproariously at the humor of comedians who entertained at Catskill resorts, but they read English and not Yiddish. The Jewish memories were not of the *shtetl* but of the East Side.

The mid 1930s were the "tipping point" between the generations, even though the foreign-born would still dominate the community for another ten to fifteen years. Adolf Hitler had come to power in Germany in 1933. Virulent anti-Semitism was on the rise elsewhere in Europe, and most especially in Poland, the home of the three million most intensely Jewish Jews. More important, the 1930s was the time when the hope or illusion of going home was lost even by those Jews who had such dreams. In the midst of economic depression in America, every other immigrant community, including even the Germans during the Hitler years and the Italians when Mussolini ruled, had a substantial rate of re-emigration. The Jews had always been different. Even in the brief moments when Europe seemed quiet, the rate of re-emigration had never exceeded one in twenty. Nevertheless, some did go back to Europe, among them Jacob David Willowski, the Orthodox believer who was briefly the chief rabbi of Chicago; Leon Trotsky, who would become the war minister of the Bolshevik revolution; David Ben-Gurion, the first prime minister of Israel; and a number of others who were not motivated by ideology but who simply felt more comfortable in their old homes.

In the first years of the Hitler era, even before the advent of war in 1939, the option of return no longer existed. Those who had been living in America as "exiles" had finally to make peace with the fact that they would live out their days in a culture and society that their children would share, but in which they would have no continuity. For company, these immigrants would have only each other. They could expect no reinforcements in new arrivals from the towns of their birth.

I recall a road company that came to Baltimore in the late 1930s to present some weeks of theater in Yiddish. The audience was very sparse, even on opening night. The manager made a tearful speech at the end of the performance in which he saw himself, and the audience, as the "last of the Mohicans." There is no photograph of his face as he delivered this speech, but the unyielding, though resigned, Orthodox faces in this book also represent the theater manager who lived for secular Yiddish culture. These images speak, too, for one of the greatest Yiddish poets in America, H. Leyvik, who had arrived in the United States before World

War I. In "To America," a poem which he wrote in 1954, he finally affirmed the new land, but Leyvik remembered how he had felt for many years:

> As soon as speech would shift toward you, I would curb
> My words, rein them in with austere restraint,
> Bind them in knots of understatement.
> My whole world and my whole life
> I held under secret locks, far from your wide open breath.

The "open breath" of America, which Leyvik had feared all his life, was its power to assimilate the next Jewish generation into the dominant culture and thus to leave him without audience and community. Only when he witnessed the death camps, after 1945, could Leyvik make himself affirm America; in a murderous age, Jews had been and remained safe and equal within its borders.

What did the children of the immigrants want of America? Some were "red diaper" babies who followed after their radical parents into socialism or communism, but most of the radical minority were young people who were denied careers by the still-existing discrimination against Jews. University faculties and the bureaucracies of big business were largely closed to Jews; there were quotas in the colleges and professional schools. Social life was rampant with exclusion. The most striking young Jewish intellectuals and writers believed that the only way to a better life was by changing the system. In the 1930s Henry Roth, in his novel *Call It Sleep*, pointed obliquely to the revolution as the way out of the ghetto, and Clifford Odets, in his play *Waiting for Lefty*, preached the revolution at the top of his voice. Despite the power of such young voices, and the fears that were caused by economic depression and growing anti-Semitism, the overwhelming majority of the children of the immigrants were not political radicals. They wanted to succeed, to realize their parents' dream of harvesting the gold of the *goldene medina*. The first generation to be born in America wanted to enjoy this world, to give the body its due. Their grandparents, who had been very poor in Europe, and their parents, who had been poor on the East Side, had been able to afford only subsistence, or less.

The overarching ideal of most of this generation was — to become American. The beards and clothes of the Old World, which some few of the immigrants still wore, and the Yiddish accents of most of their parents were not honorable carry-overs from a culture to be respected; they were reminders that these young new Americans could sing "Land

5

where my fathers died; land of the Pilgrim's pride" not as a literal truth but only as a metaphor or, at best, as the rhetoric of children who had been adopted reluctantly and were not much wanted.

These self-conscious new Americans wanted their parents to help them by becoming less foreign and less idiosyncratic. Children put enormous pressure on their parents to dress like Americans. In the picture in this book of an older lady with her daughters and daughters-in-law, the mother figure has clearly been put into "proper clothes" for this occasion. I have no doubt that this woman was most at home in the kerchief of her earlier years, which she perhaps was wearing that day before she was dressed for the picture. This desire to retouch the immigrants persists to this day, when their grandchildren are into middle age and beyond, and the quest for "roots" is in fashion. In the film *Avalon*, about an immigrant Jewish family in Baltimore, a critical incident was a quarrel between brothers because the family did not wait for the poorest and most rambunctious among them when he came late to Thanksgiving dinner. This is a story retouched to make it more "American." A quarrel of such bitterness could not have occurred over Thanksgiving, for this American holiday was not celebrated in the immigrant generation as a central family festival. This fight could have erupted only over the Passover seder, where it matters if the ritual begins without everyone at the table. The author of the film, a grandchild of these immigrants, has put new clothes on his grandparents for the movie cameras, just as a generation before the daughters and daughters-in-law dressed up their mama for Arnold Eagle's still camera.

The immigrants whom Arnold Eagle saw in the 1930s are gone. What can we make of the memories that are evoked by their faces? Superficially, the new, bustling ultra-Orthodox communities in Brooklyn, in Monsey and Lakewood, in the outer reaches of the New York area, in Baltimore, and in Los Angeles seem to be continuations of those who transported the *shtetl* with them to the East Side at the turn of the century. The images seem the same: ultra-Orthodox Jews wearing as their everyday clothes the garb that Tevye and his rabbi wear on the stage in *Fiddler on the Roof*. But these new communities, which were founded after 1945, are radically different from the ultra-Orthodox men and women who were still alive in the 1930s. The newer communities came as groups. They transplanted themselves after the Holocaust to the United States because they could not return to their birthplaces which refused

to have them back. They came to America because it offered them the chance to live their old lives, unchanged. The situation of the earlier arrivals during the era of mass migration had been fundamentally different: almost everyone came as an individual, to improve his personal destiny, and not as part of communities that were transplanting themselves. The forms of association of the earlier immigrants had been fashioned in the United States and not brought over from Europe. The newest arrivals were a different breed. They came after 1945, bringing along their rabbis and their forms of authority. They have succeeded in educating their children in parochial schools of their own. There are now many American-born young who live, and dress, like their fathers and mothers. This present ultra-Orthodox community continues to look forward with perhaps somewhat exaggerated certainty to retaining in America the form of life that their ancestors defined. The ultra-Orthodox of the 1930s were increasingly isolated individuals who knew that, as they were, they would not be replaced.

But there is a living legacy from the East Side, to which every element contributed: the ultra-Orthodox, the revolutionaries who made speeches in Union Square, and the masses who simply came to find a better life. The cliché has often been repeated that being Jewish is being like everybody else, only more so. This is true, but only in part. Jewish immigrants and their descendants, as they have integrated themselves into America, have behaved like all other immigrant communities, but have also behaved uniquely different. All immigrants, of whatever origin, felt strange in the new land, and their children and grandchildren wanted to be accepted by the American majority. All immigrant communities have retained ethnic memories of some kind for several generations. While sharing in these processes, the Jews have gone their own way.

Perhaps the strongest of all Jewish inheritances is the conviction that being Jewish is not merely ethnic memory, but that this identity governs moral conduct. Every other ethnic minority, as it has risen in America, has changed its politics to reflect its changing class interests. The Jews are the only "haves" in America who continue to vote against the rest of their economic class and with the poor. Jews have remained overwhelmingly liberal in favor of the welfare state. The explanation that is often offered, that Jews behave this way because they still remember their own days of immigrant poverty, is not adequate. Other ethnic minorities were as poor or poorer on arrival, and most of their affluent

are now conservatives. Among the Jews, grandparents who were pious, or who chose to be secular progressives, seem still to be alive and pointing their fingers at their descendants, to remind them that a Jew is commanded not to turn away from the misery of others.

All immigrant communities worked hard at self-help, at taking care of their own; all varieties of newcomers to America retained ties to the lands of their birth. The Jewish passion for associating with one another, and for helping other Jews all over the world, remains the most intense of all such interests. Some lessening is apparent now as men and women of the third generation, the great-grandchildren, are coming to maturity. Even so, no other immigrant group in America has remained actively united for over a century, caring for its own and, since 1948, for the state of Israel. The passion that the immigrants brought with them after 1881 was enshrined in such songs in Yiddish as "Whatever else we might be, we are all of us Jews." This feeling still echoes.

A third legacy, a quest for values, has begun to appear in recent years. This book, which revives the images of nearly sixty years ago is, indeed, part of this newest stirring. The renewed interest in the culture of the immigrants is a version of "Hansen's Law," that what the children of the immigrants cast away is revived by the grandchildren. American Jews are now sufficiently American that they can comfortably reclaim bearded Orthodox immigrants, or revolutionaries, as their progenitors. Such figures seem, indeed, to be more interesting than the average grandparent, who is remembered as part of the ascent from sweatshops to suburbia.

At an uncertain time, the dominant questions today are about those values which outlast both success and failure. Most American Jews remember the history of their families as beginning on the East Side, but the East Side can no longer be the new beginning of American Jewish experience. Some are now looking at the faces of these immigrants to find links to an earlier past. Wisdom, and even role models, can perhaps be found in the immigrant ancestors of a century ago. They brought with them personal experience of the intense Jewish life into which they were born. This book is one gateway to all the centuries of the life in Europe to which the immigrants still belonged. The pictures in this book are a form of resurrection.

ARTHUR HERTZBERG

She came to America not for herself, but for the children, circa 1935

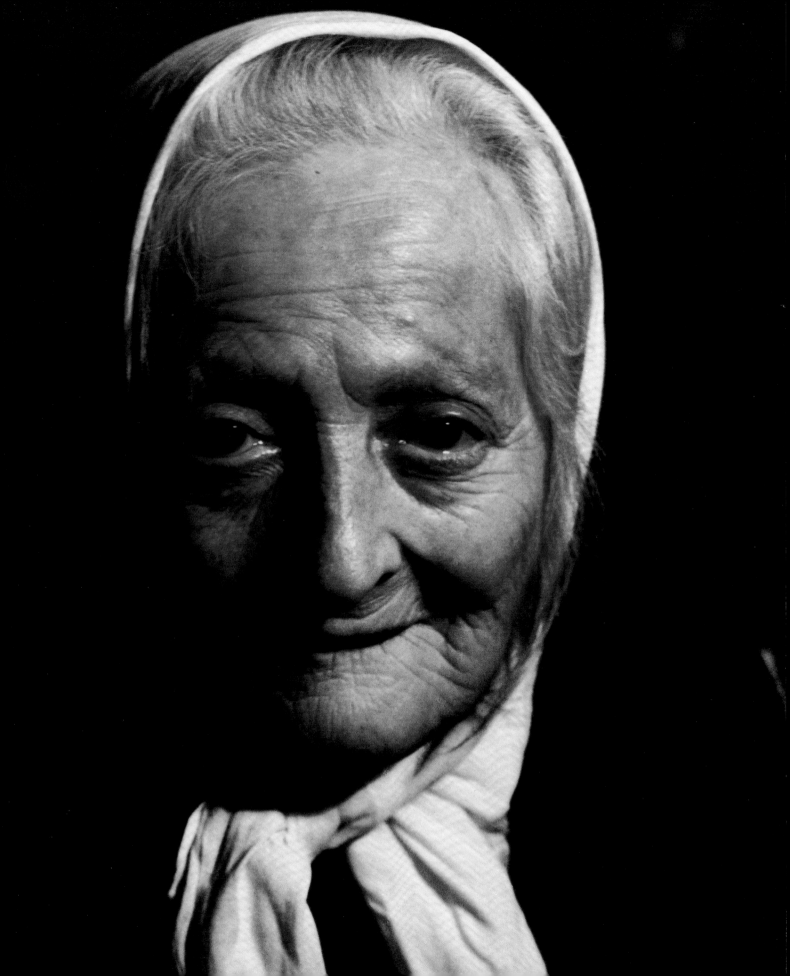

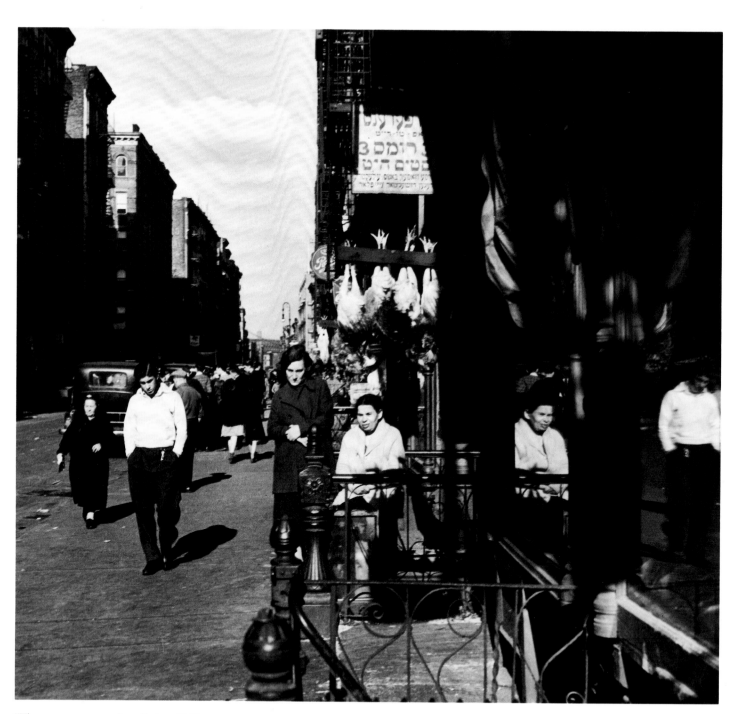

"Three rooms, steam heat," circa 1935

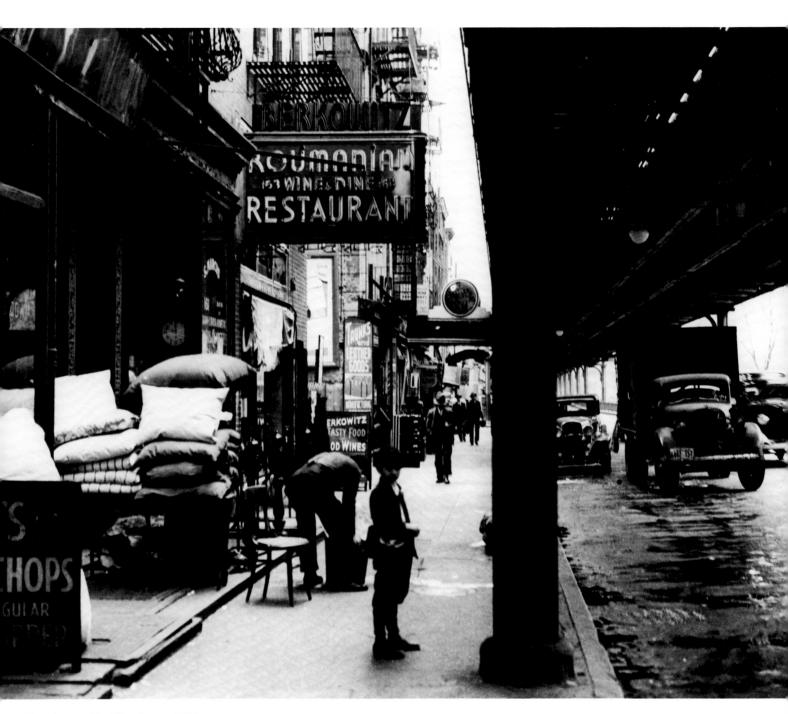

First Avenue El, Allen Street, 1935

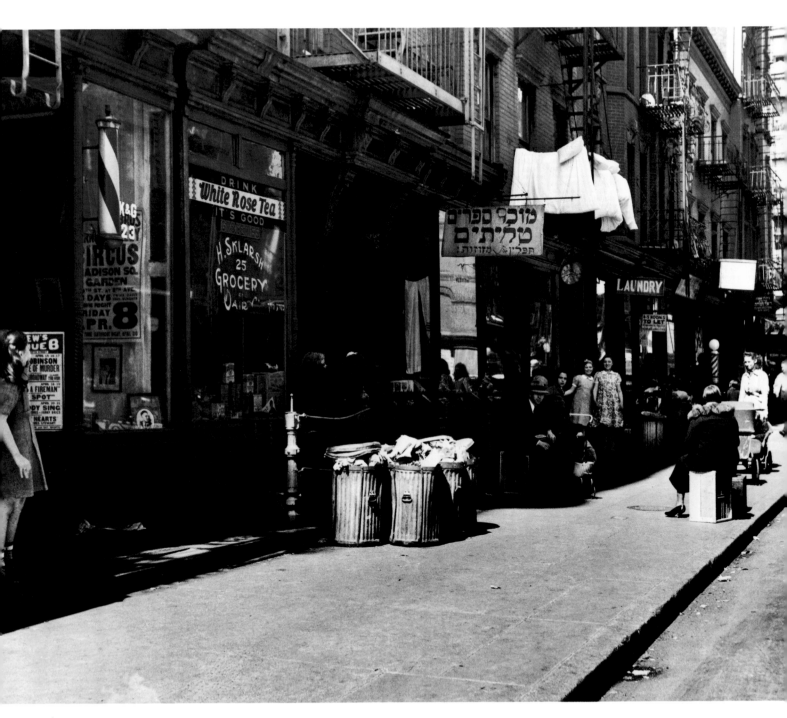

Street scenes, circa 1935

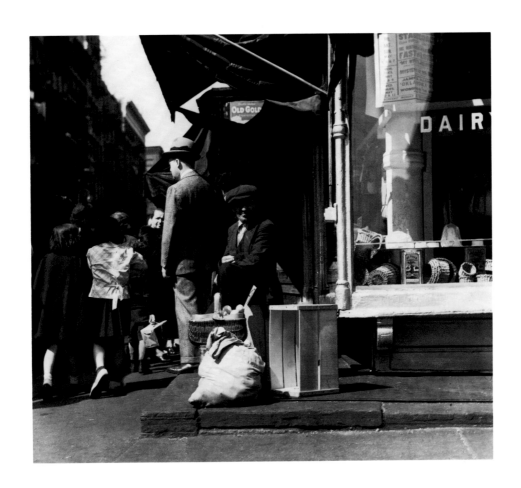

OVERLEAF, Children at play, circa 1934

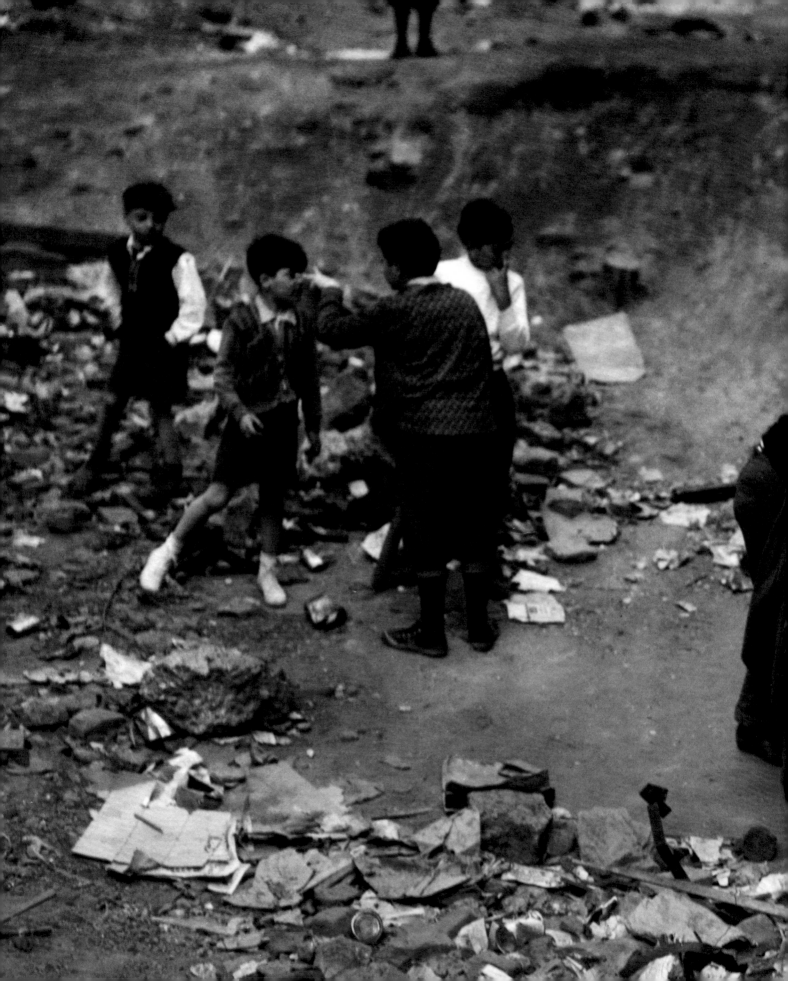

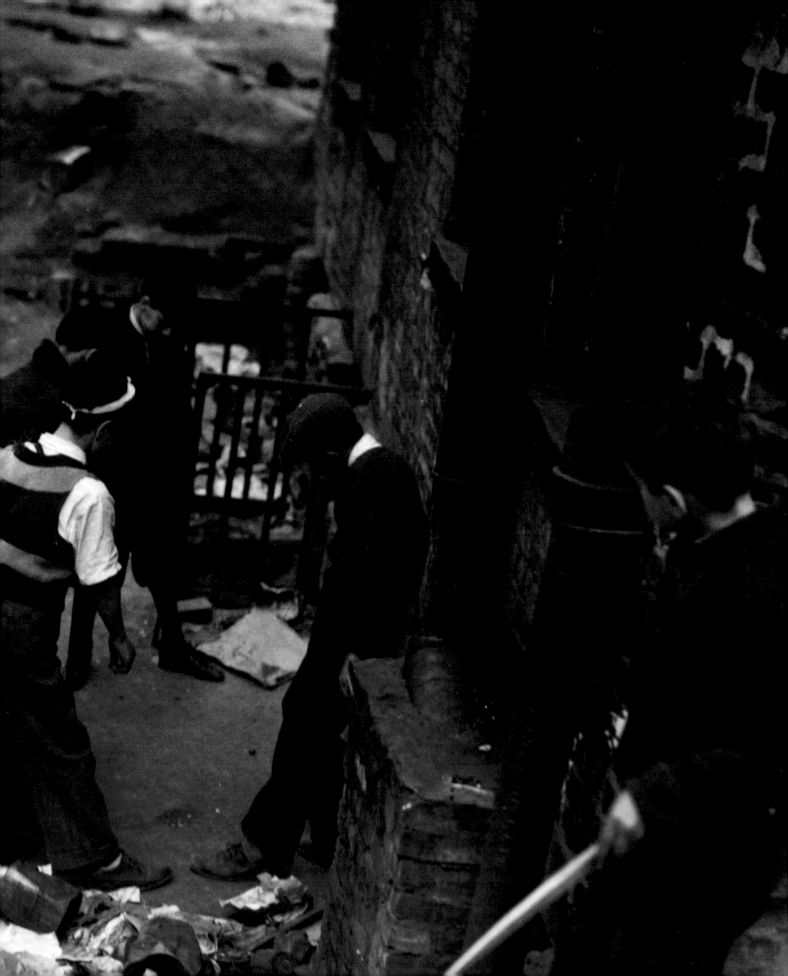

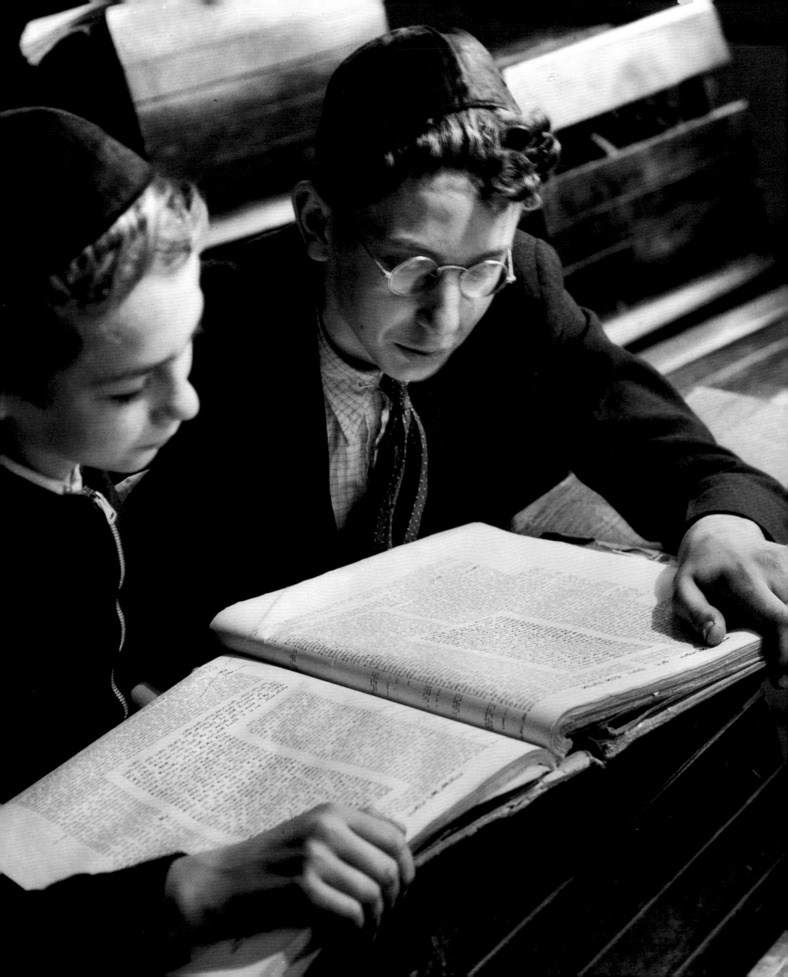

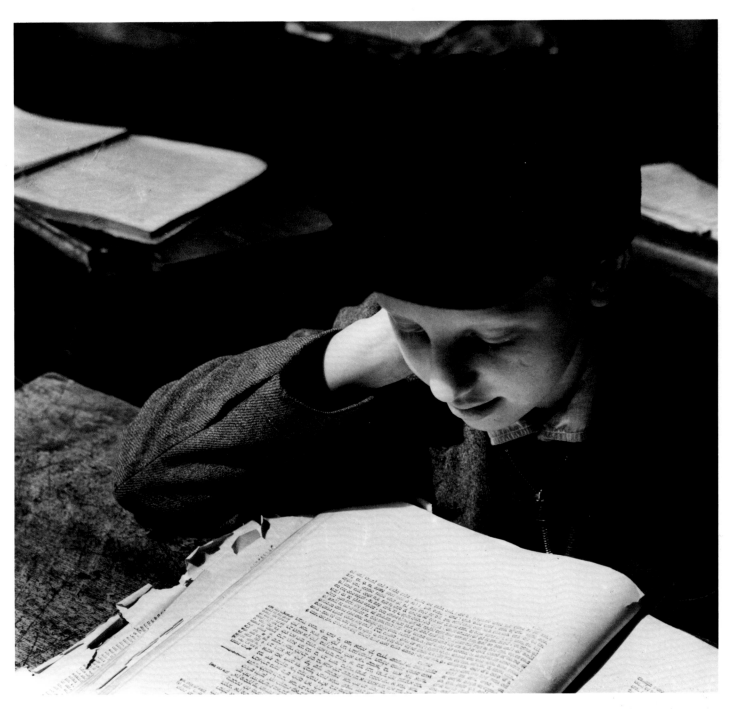

A few studied the Talmud, even in America, circa 1935

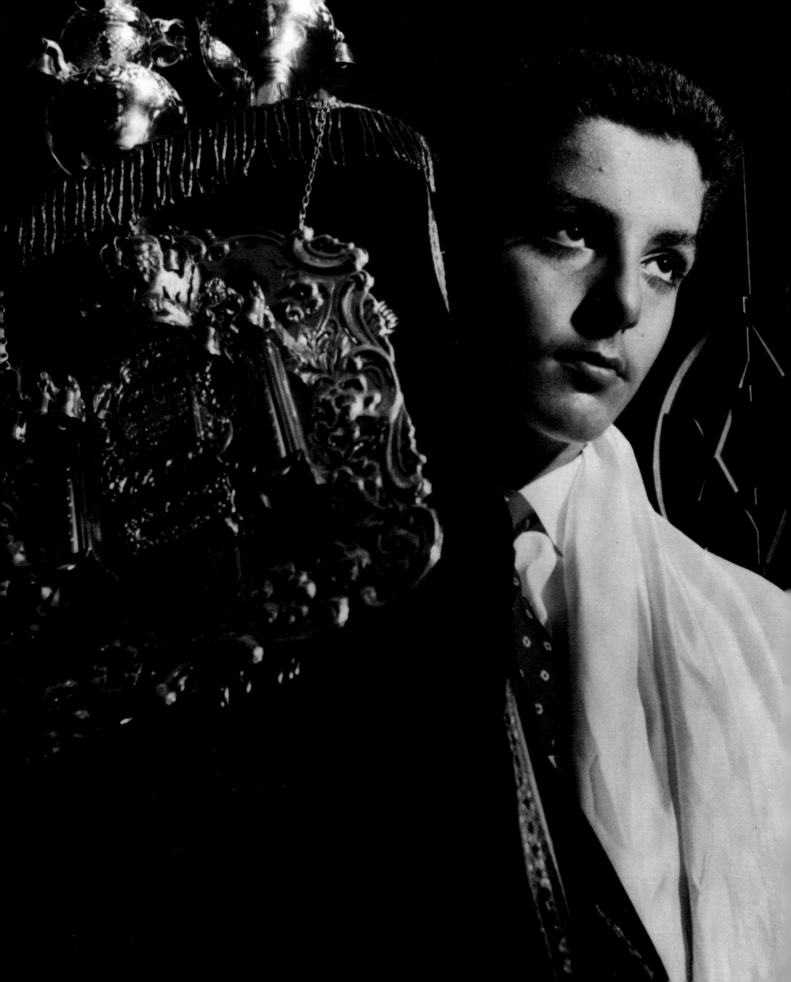

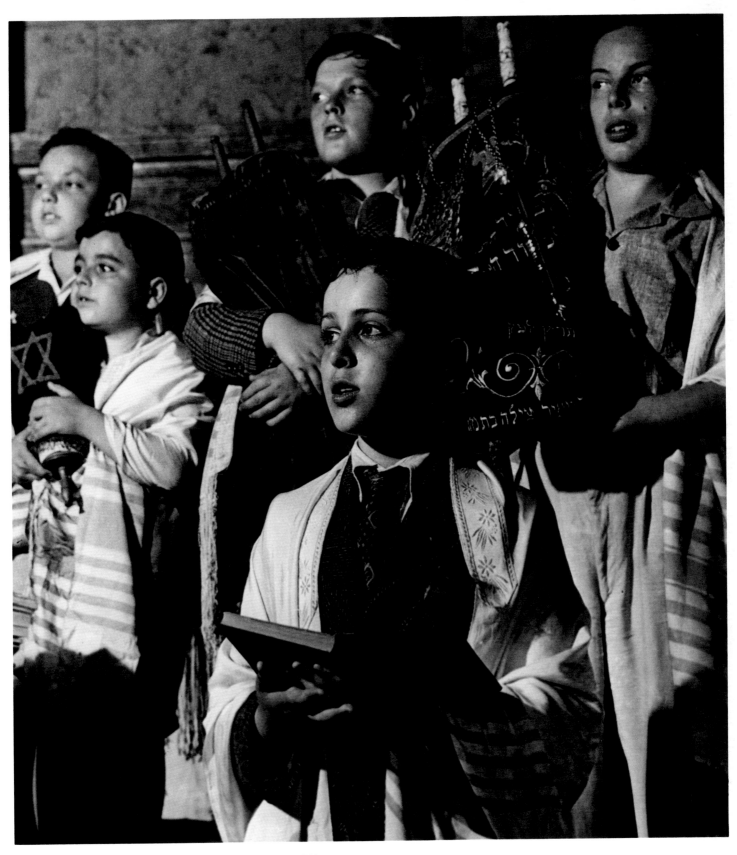

Boys learning to carry on the traditions of the synagogue, 1940

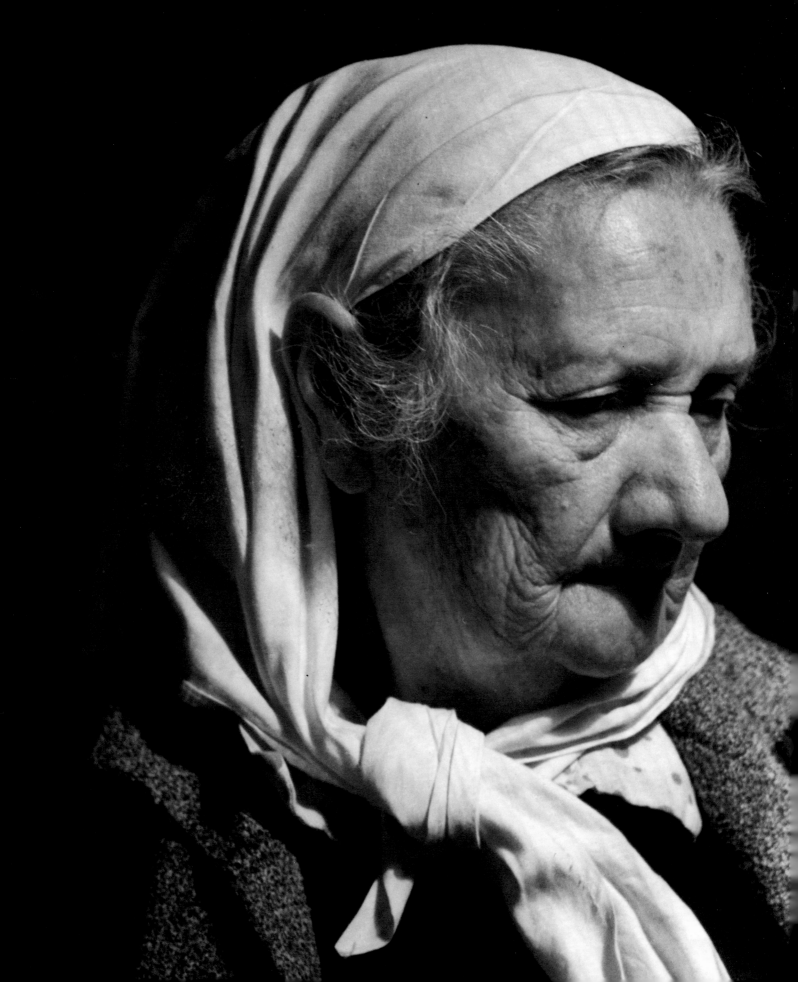

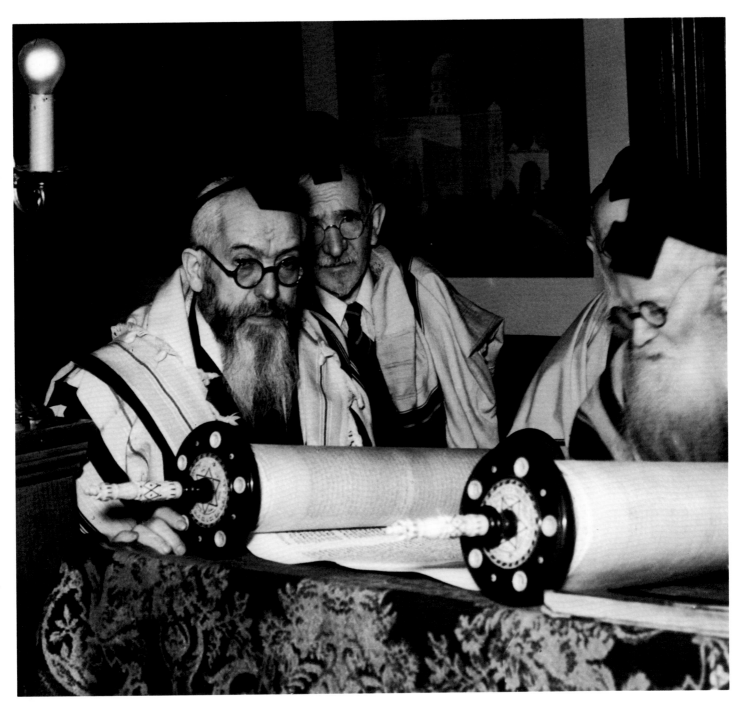

Reading the Torah on a weekday morning, 1935

OPPOSITE, "Blessed art thou O Lord,
our God, sovereign of the universe, who has
created me according to His will."

21

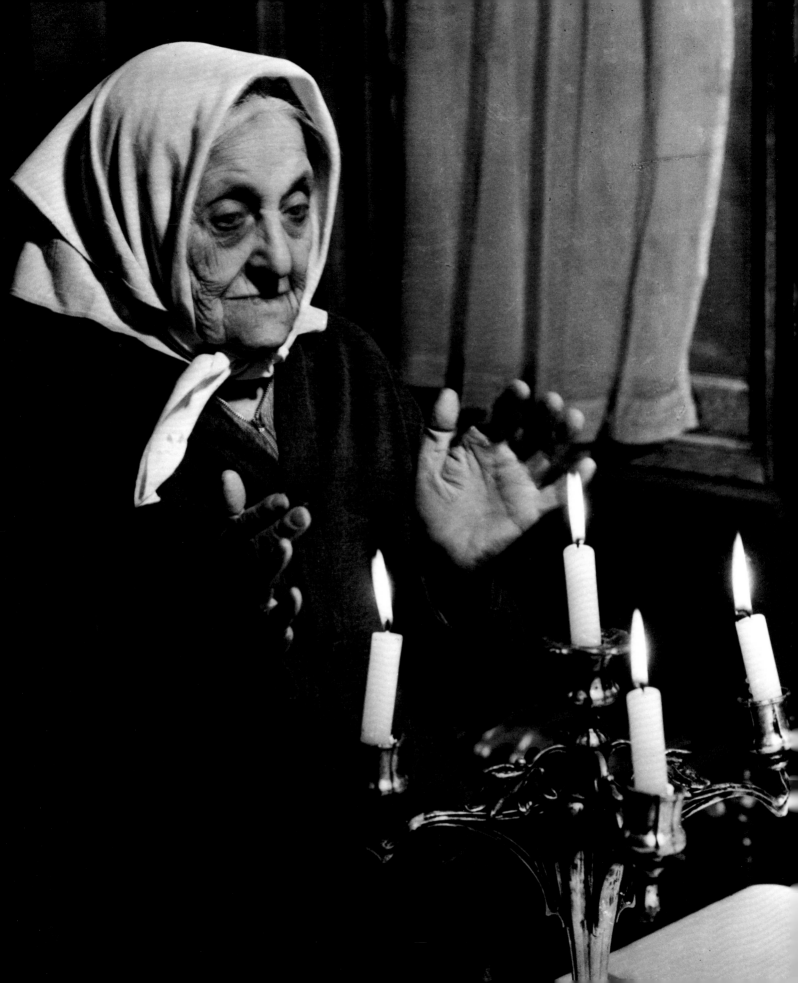

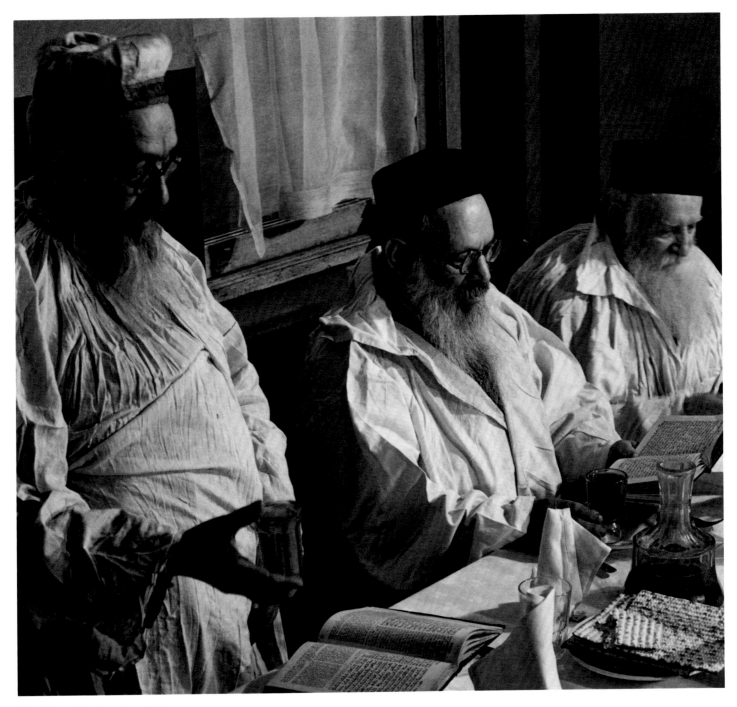

An old-world seder, circa 1935

OPPOSITE, Blessing the Sabbath candles, "God of Abraham, Isaac, and Jacob, have compassion for my children."

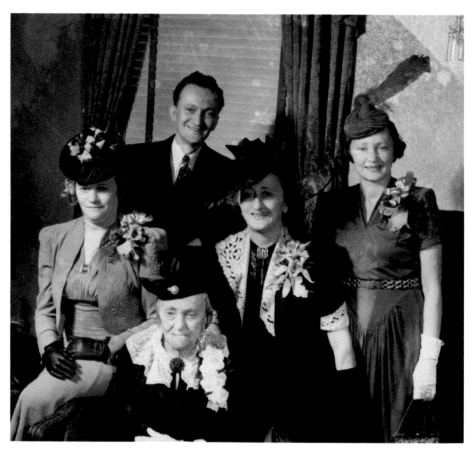

Mother and children, embracing America, circa 1945–50

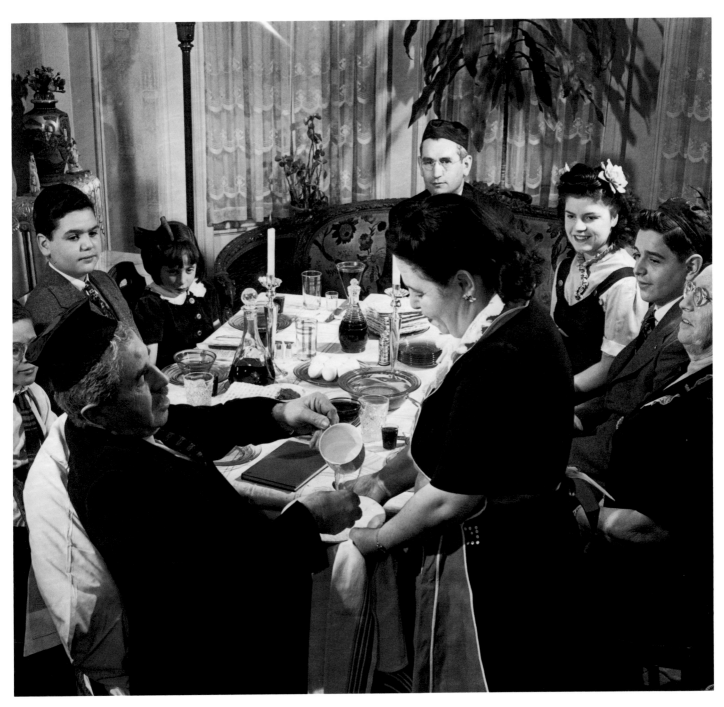

A seder in America

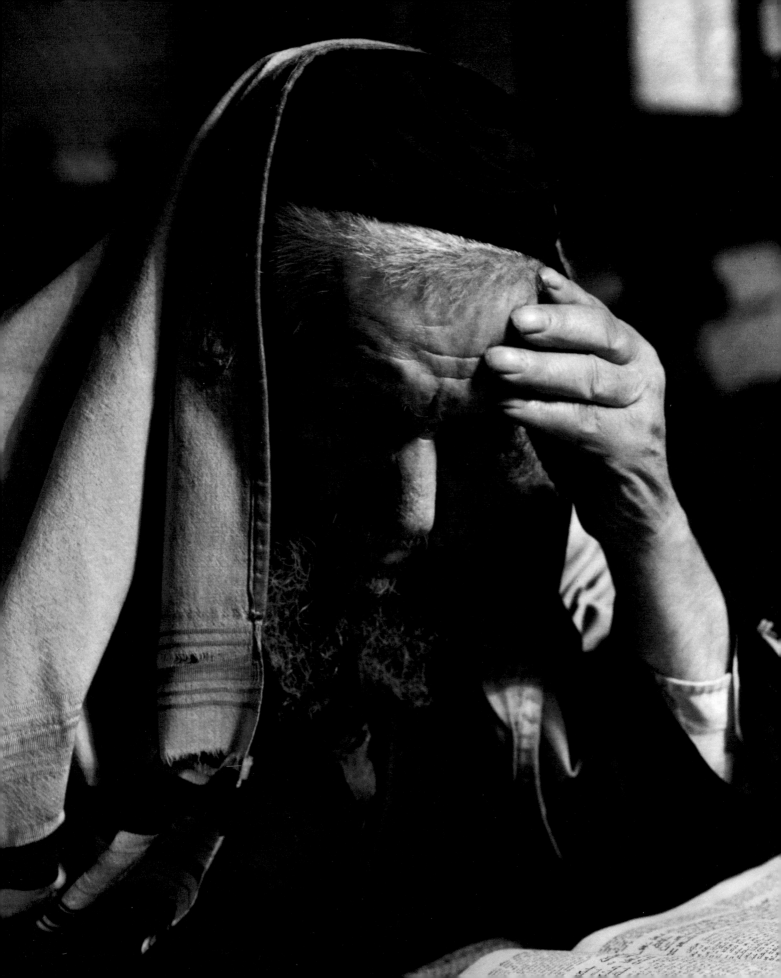

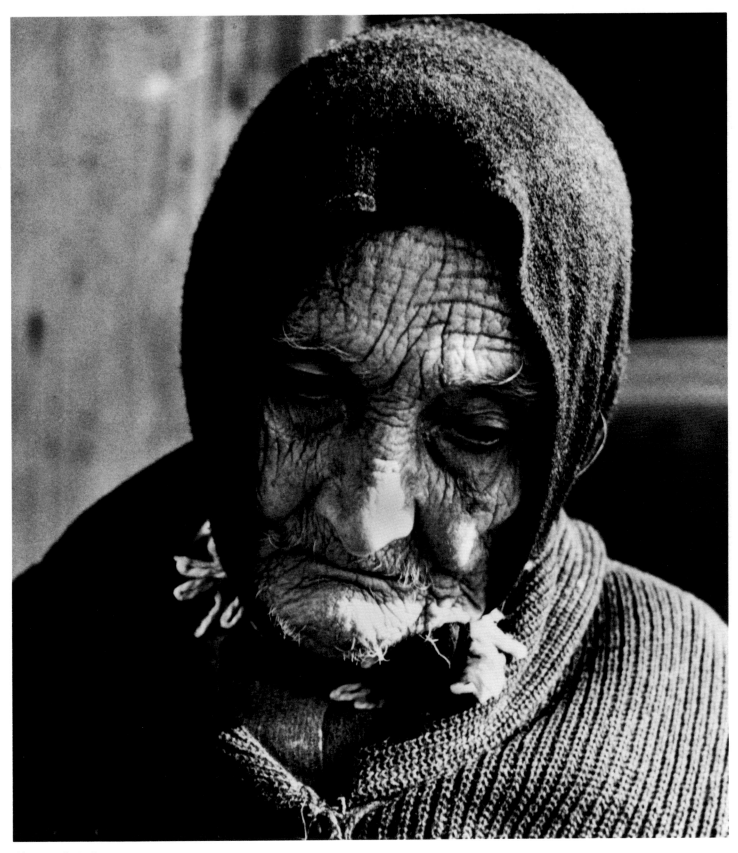

Alone, with God

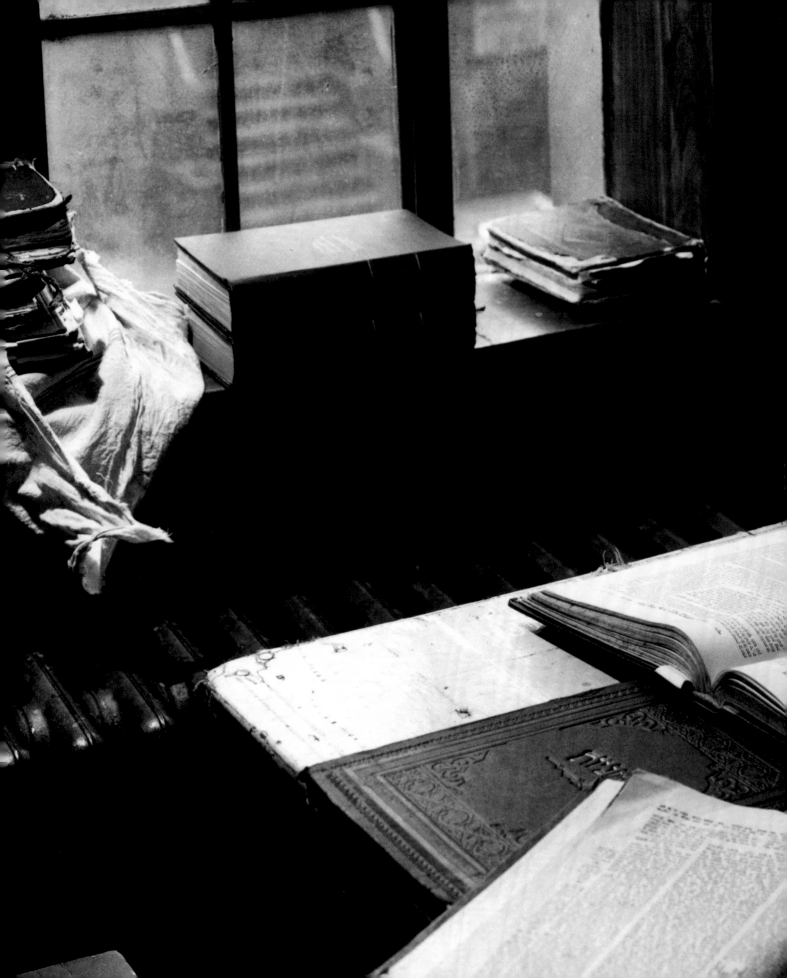

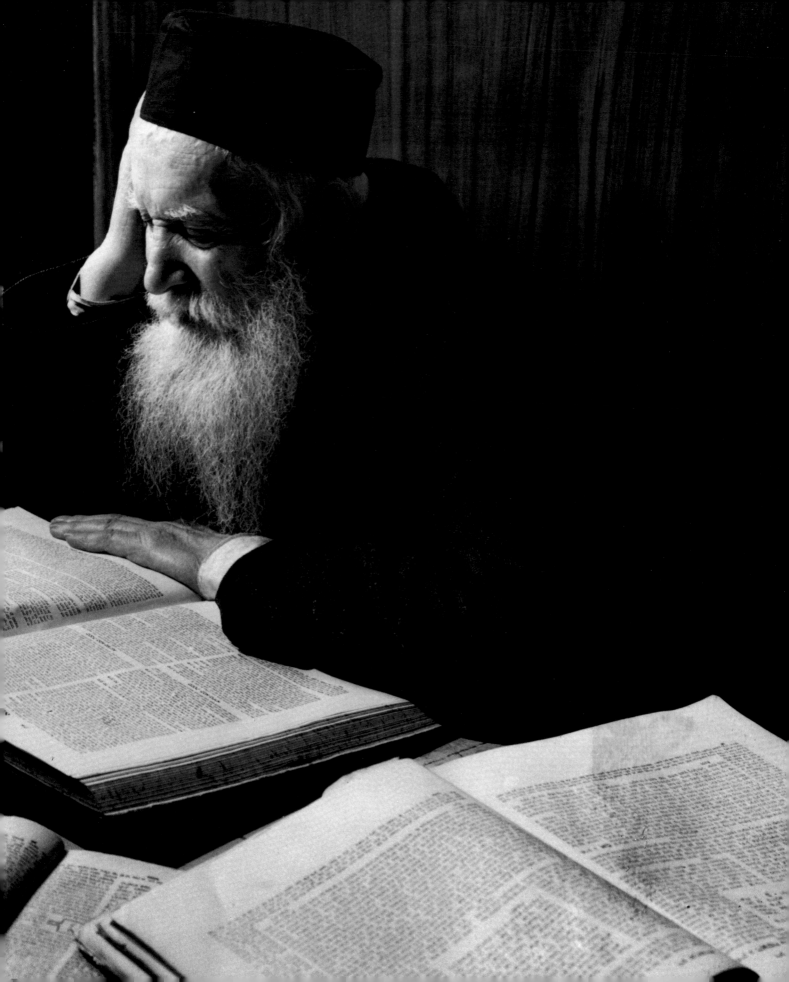

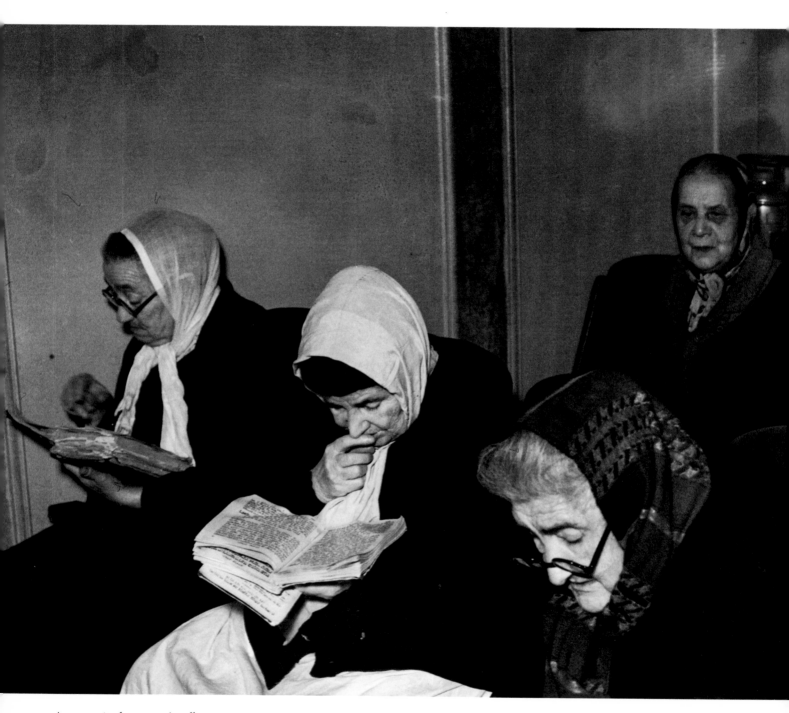

At prayer in the women's gallery

PREVIOUS, Swimming in the sea of the Talmud, circa 1933

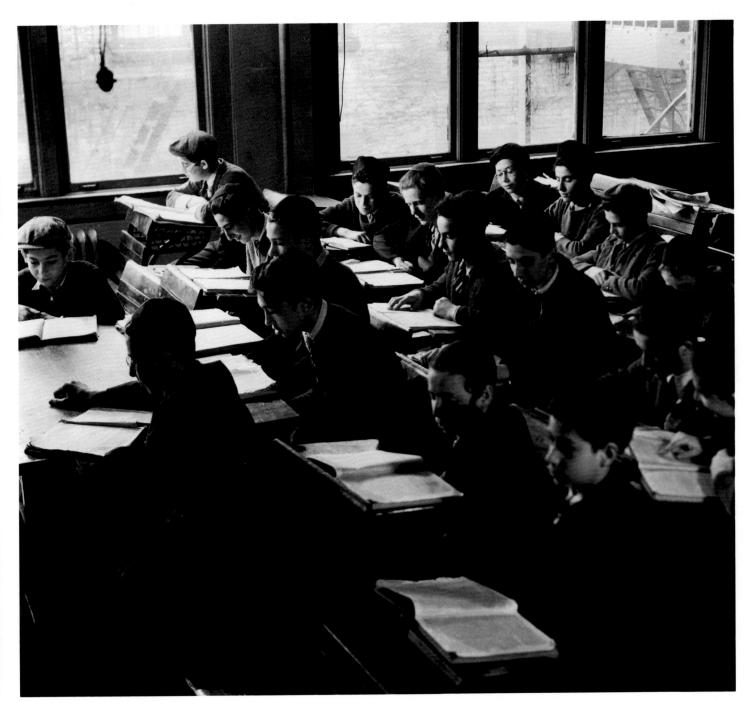

The yeshiva, circa 1935

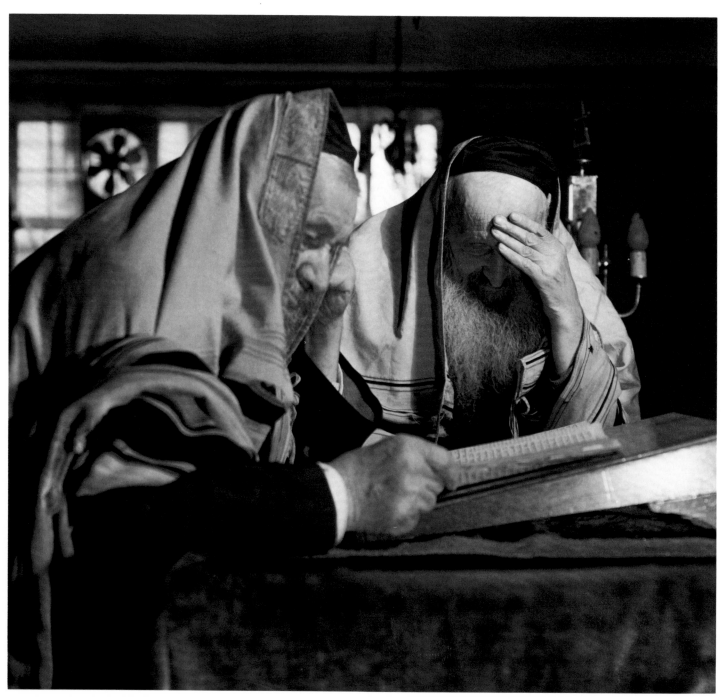

Meditating on The Word

OPPOSITE, "His desire is the law of the Lord."

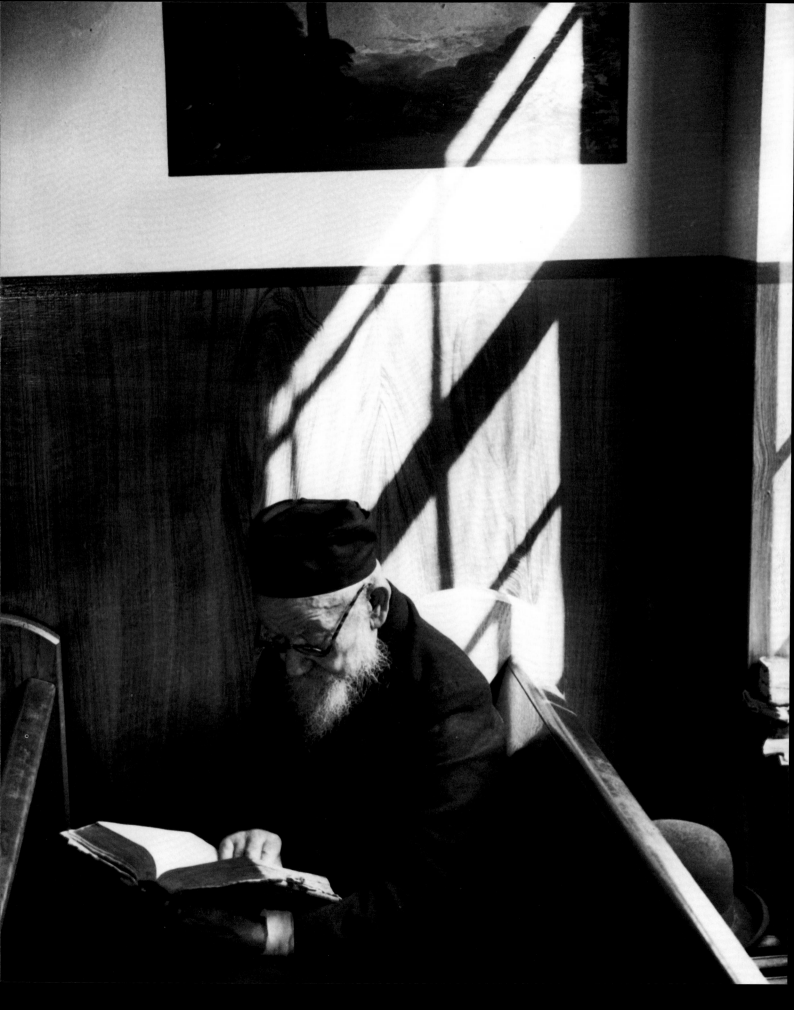

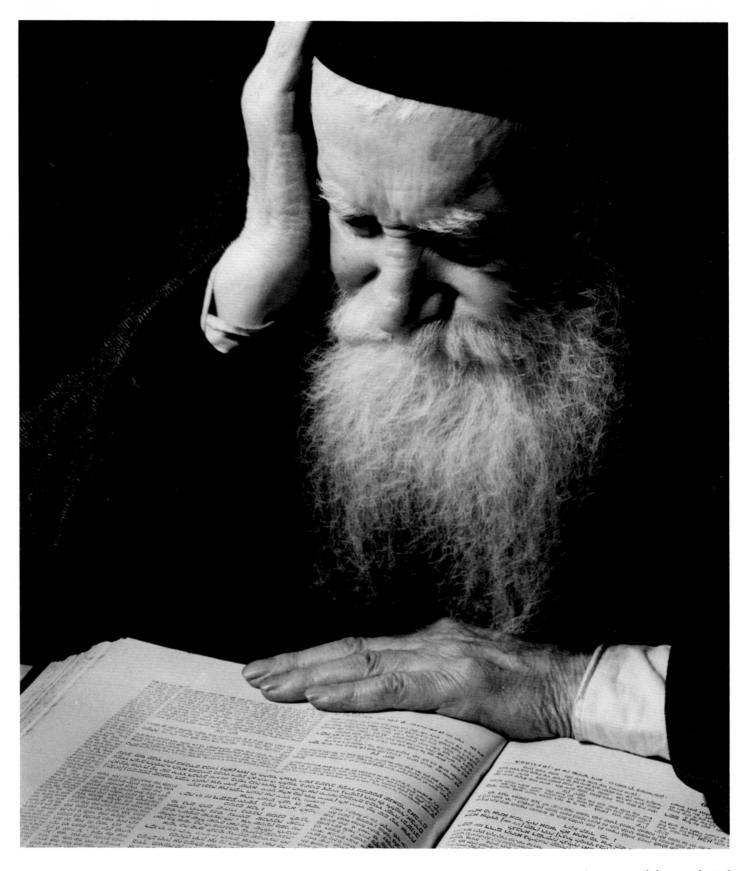

At prayer with heart and mind

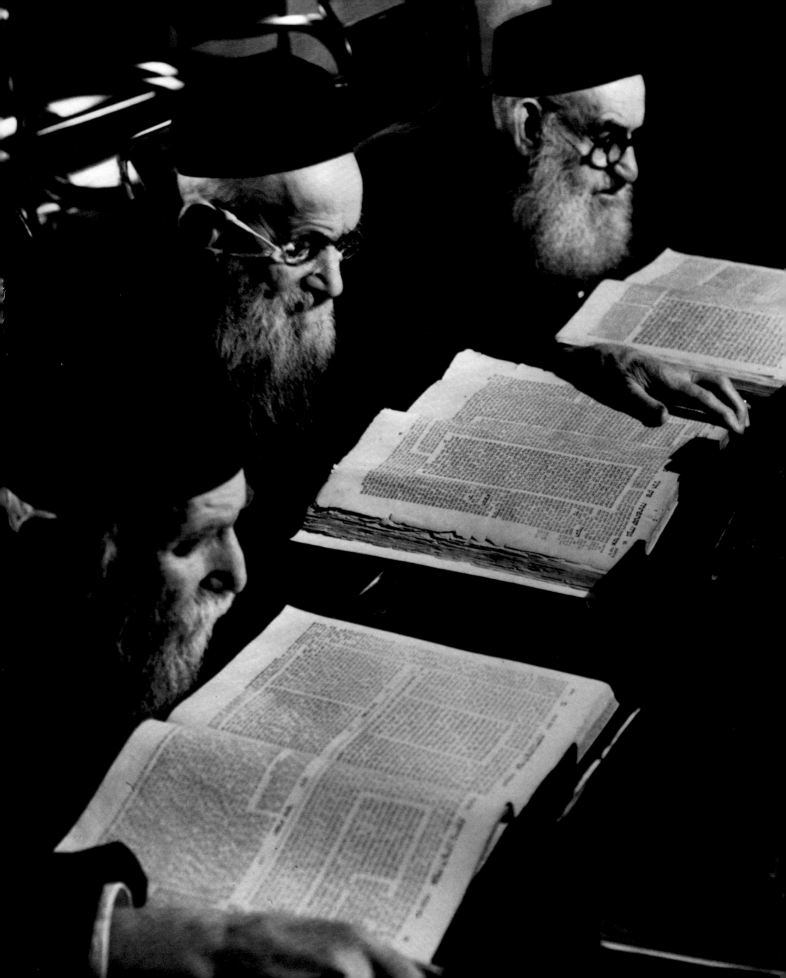

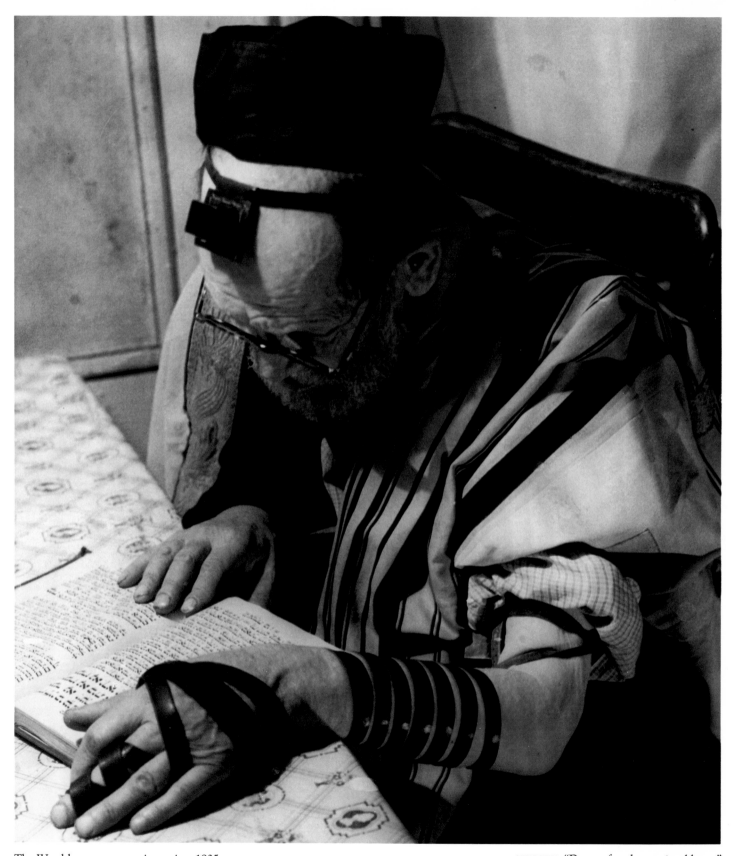

The Word has many meanings, circa 1935

OPPOSITE, "Do not forsake me in old age."

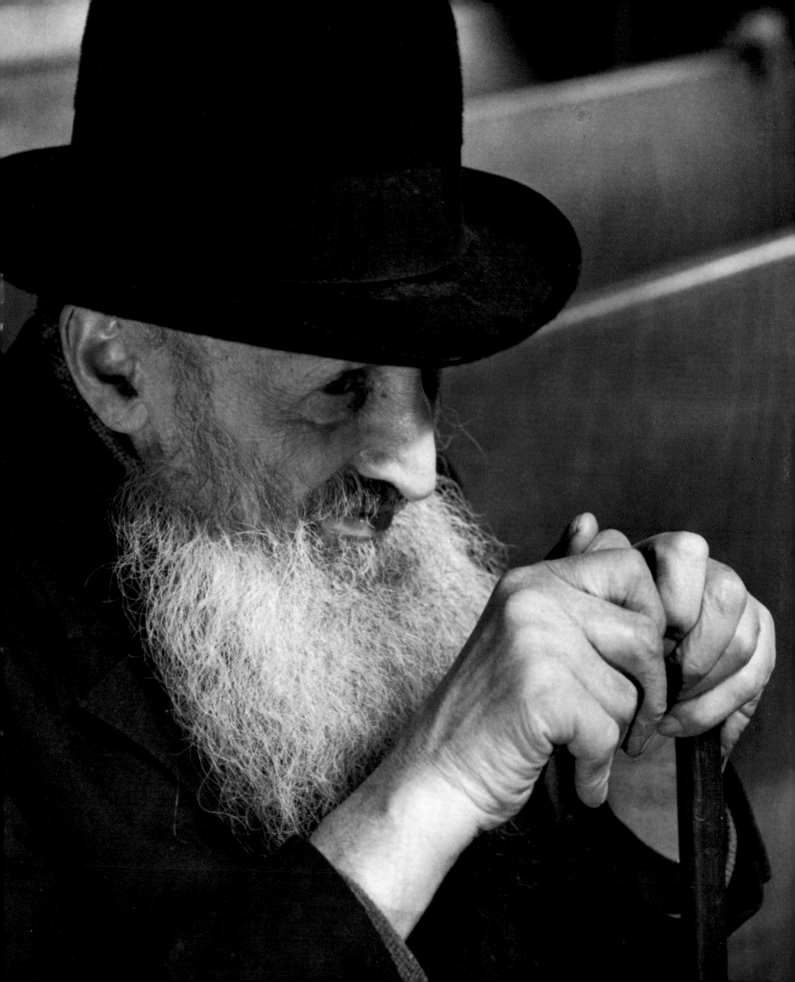

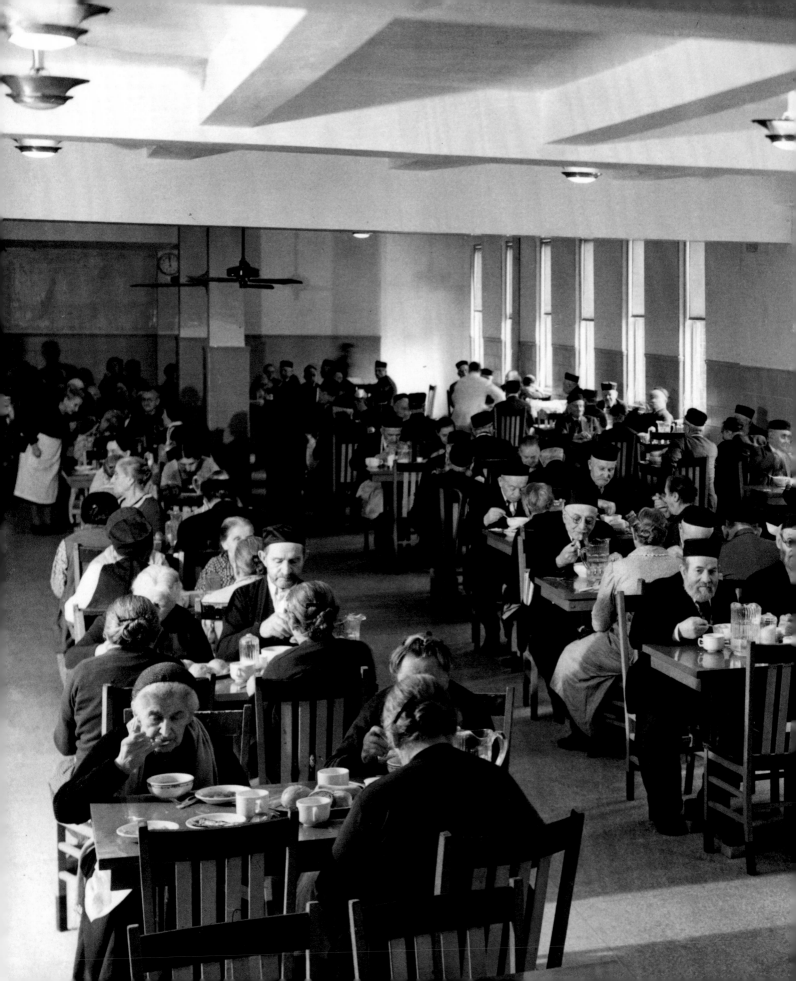

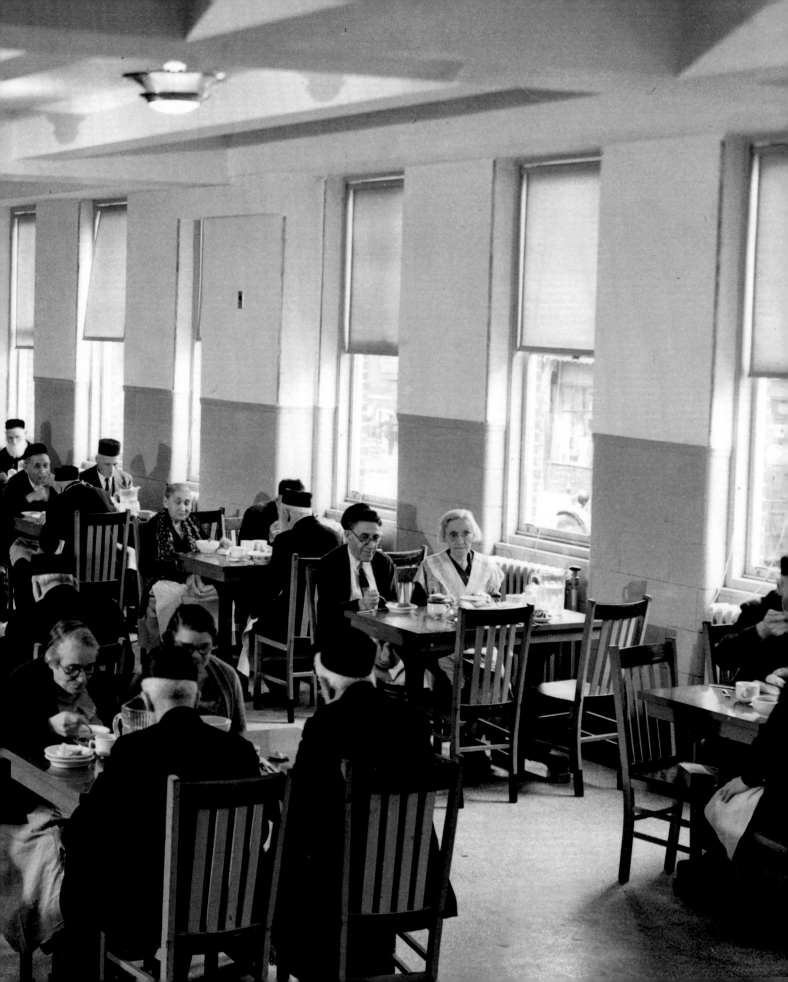

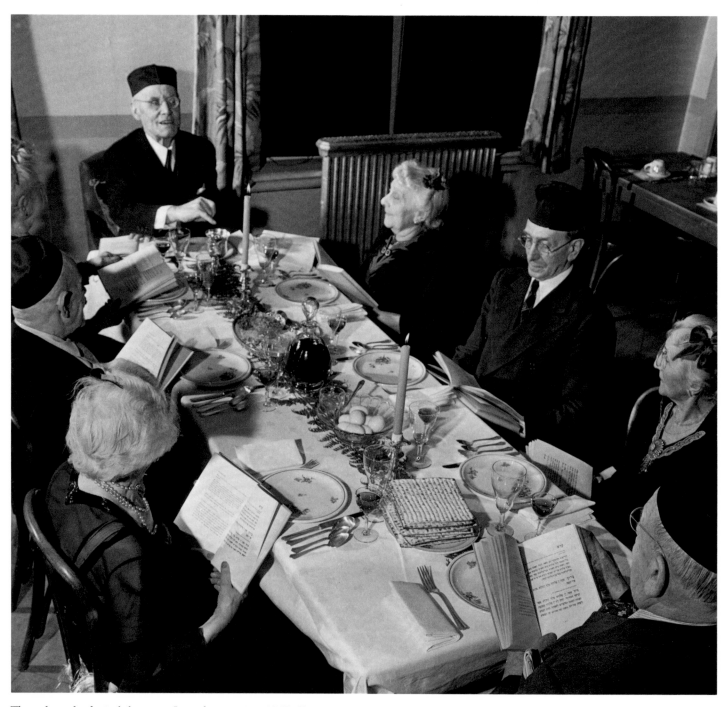

The seder—the festival that most Jews observe, circa 1945–50

PREVIOUS, Dining room in the home for the aged, circa 1935

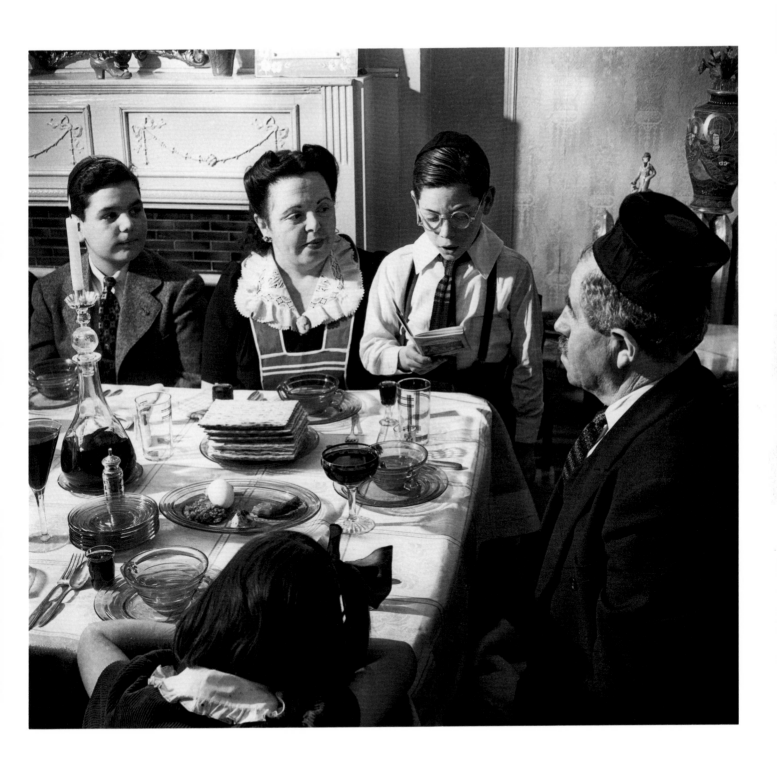

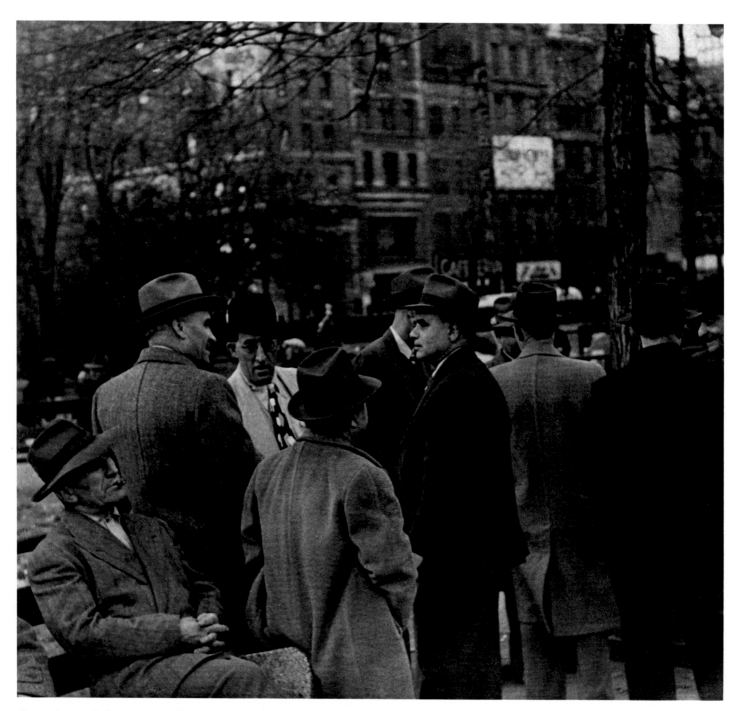

Union Square. Debating the world as it is and ought to be.

OPPOSITE, The tenements, 1938

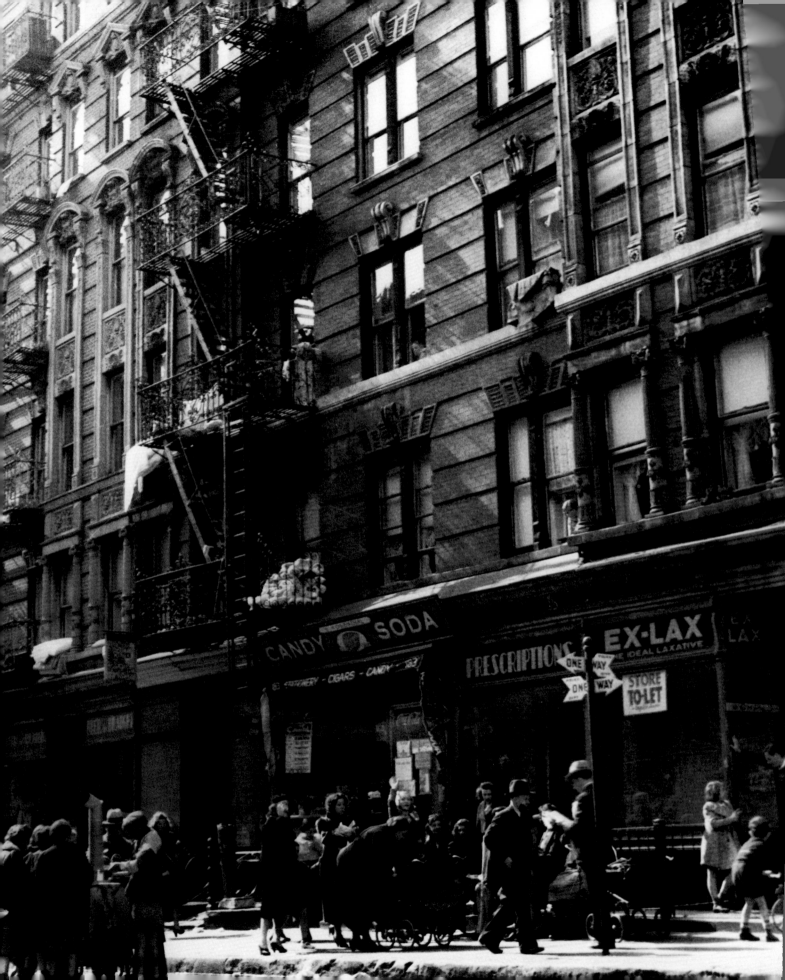

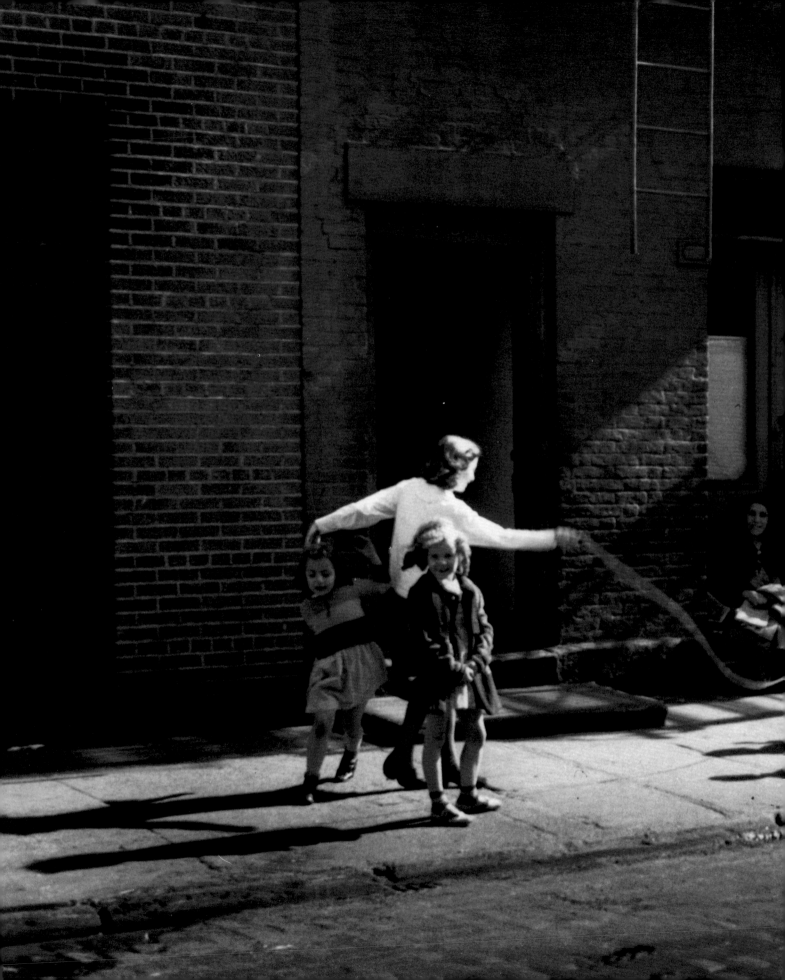

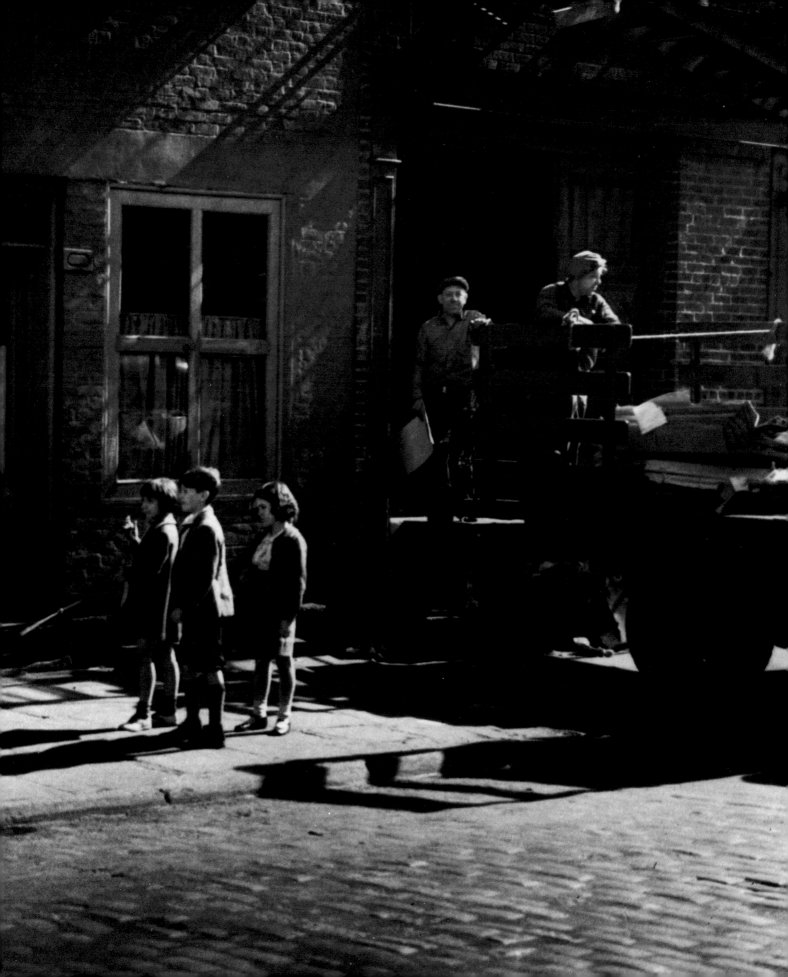

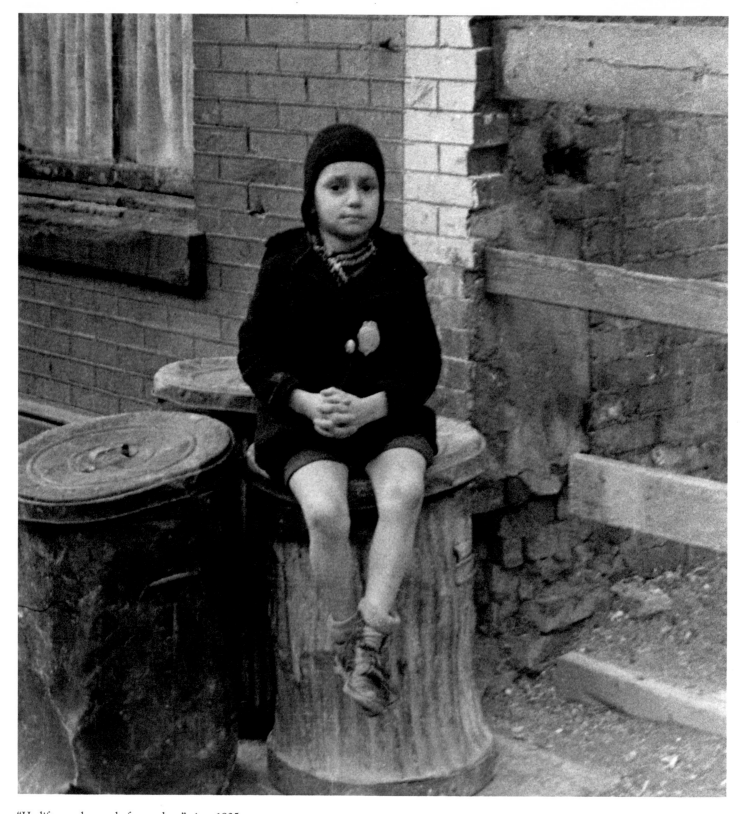

"He lifts up the needy from ashes," circa 1935

PREVIOUS, School recess on the sidewalk.

OPPOSITE, Story time on the Lower East Side
at the nursery of the Educational Alliance, circa 1948

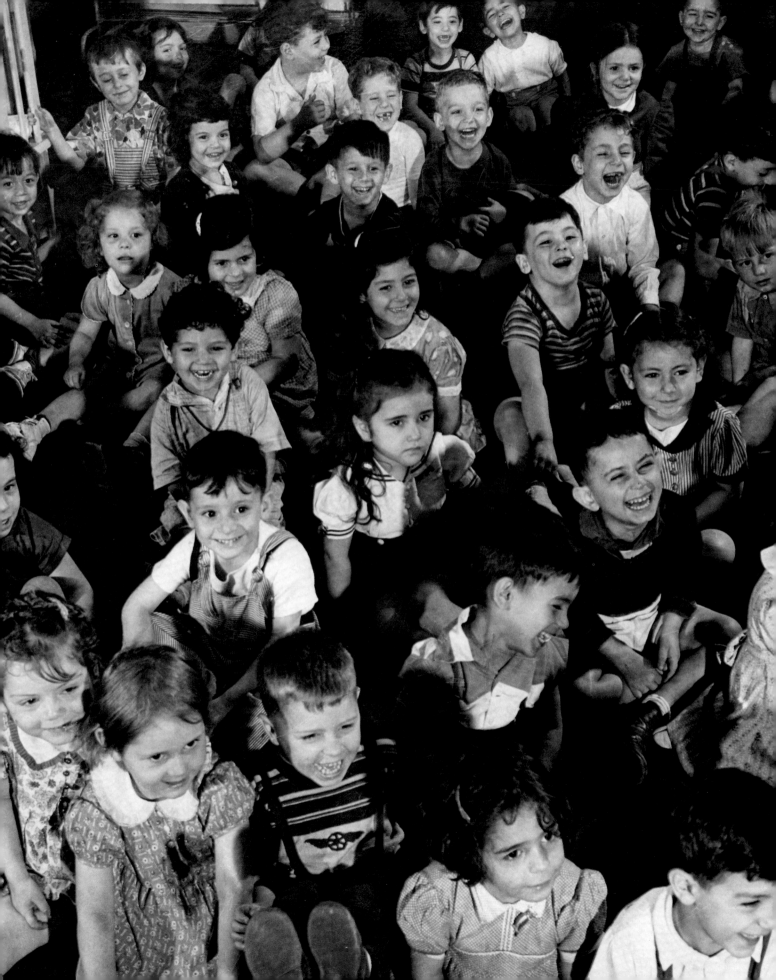

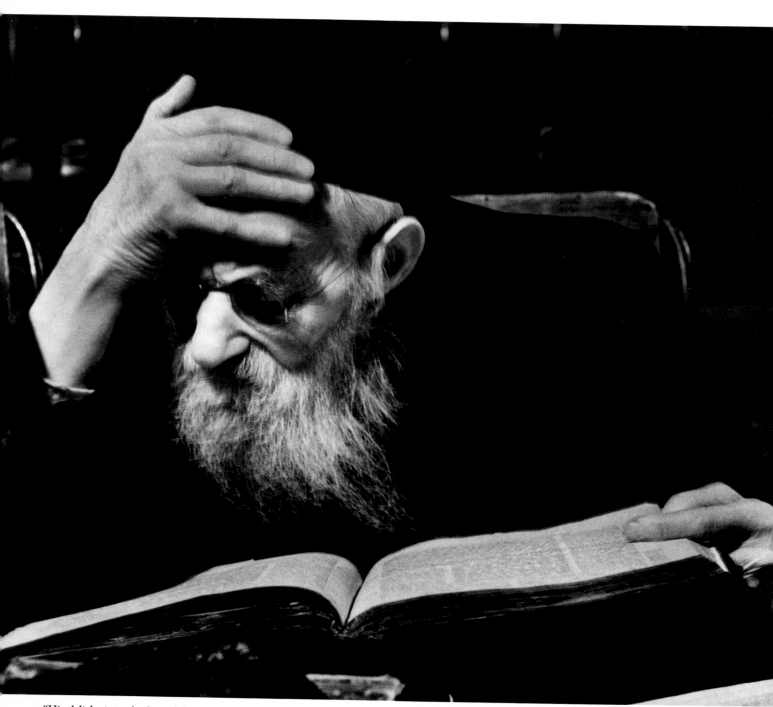

"His delight is in the law of the Lord."

OPPOSITE, The storekeeper, circa 1935

48

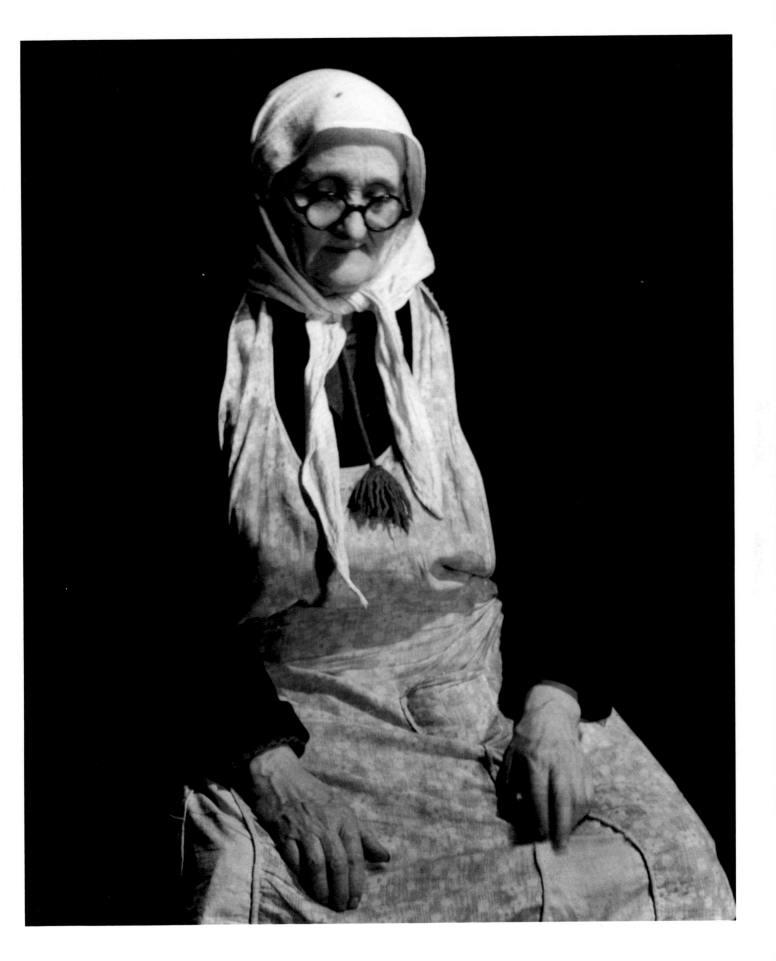

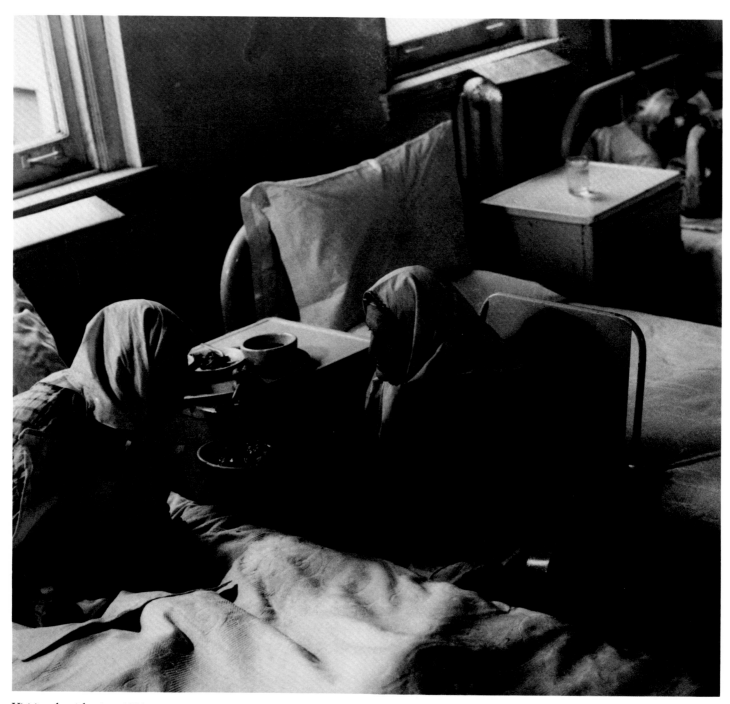

Visiting the sick, circa 1934

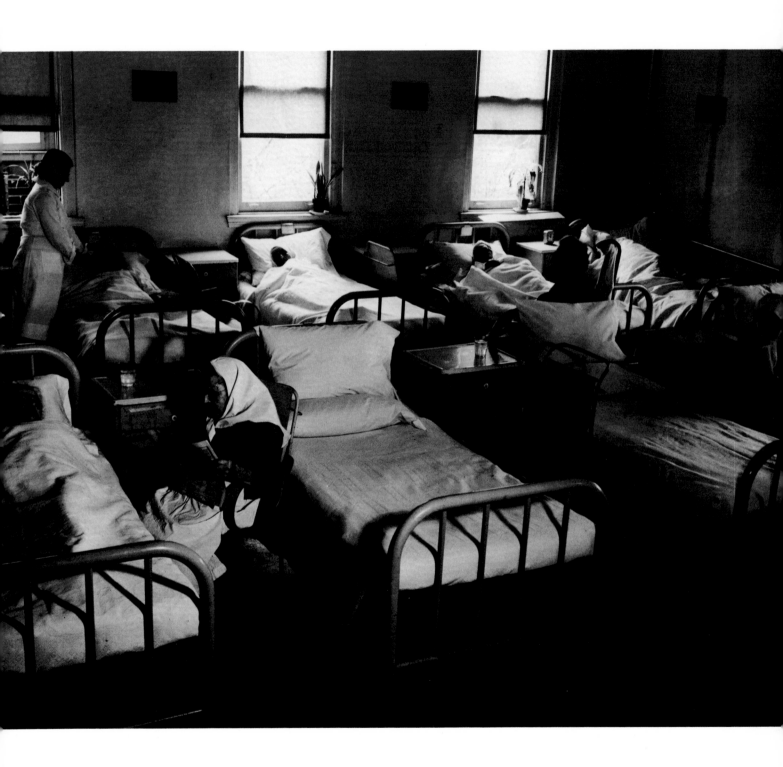

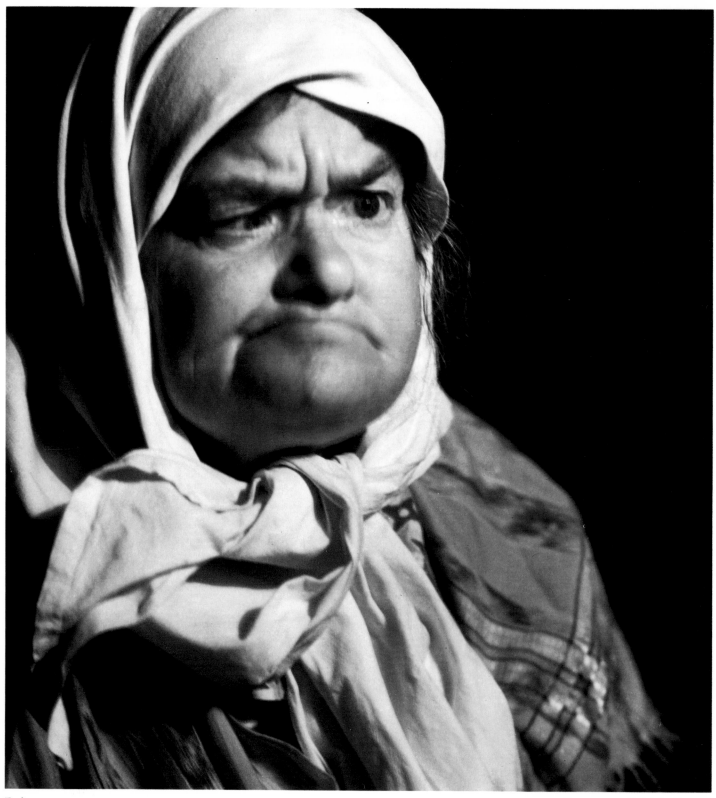

Defiance

OPPOSITE, Resignation, circa 1935

52

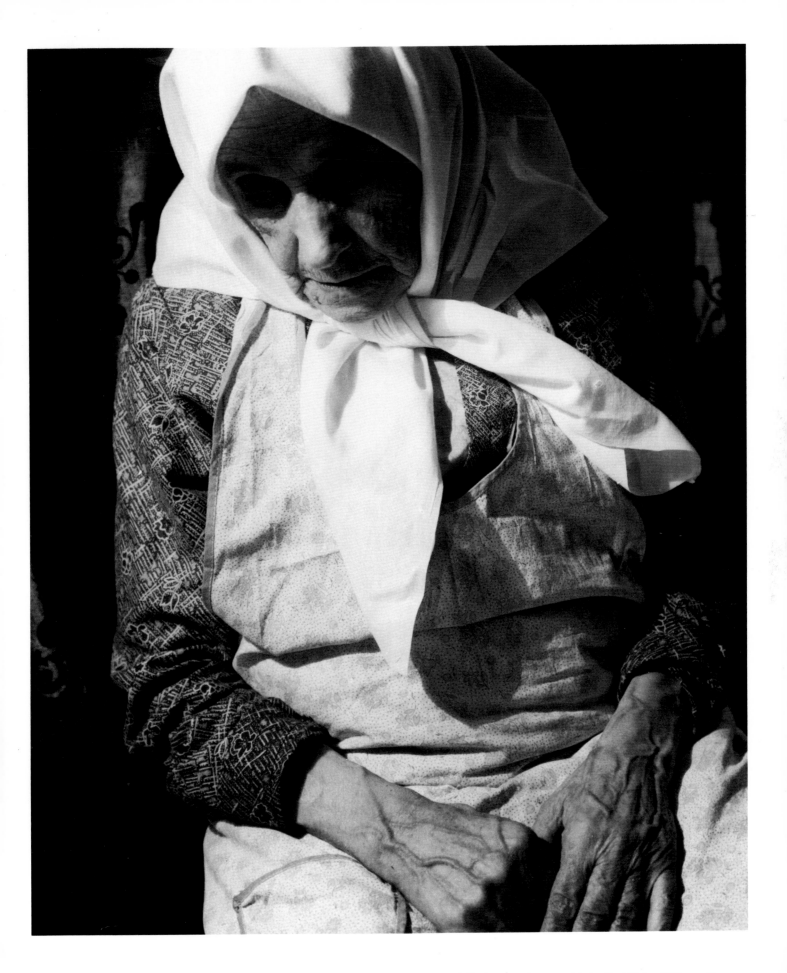

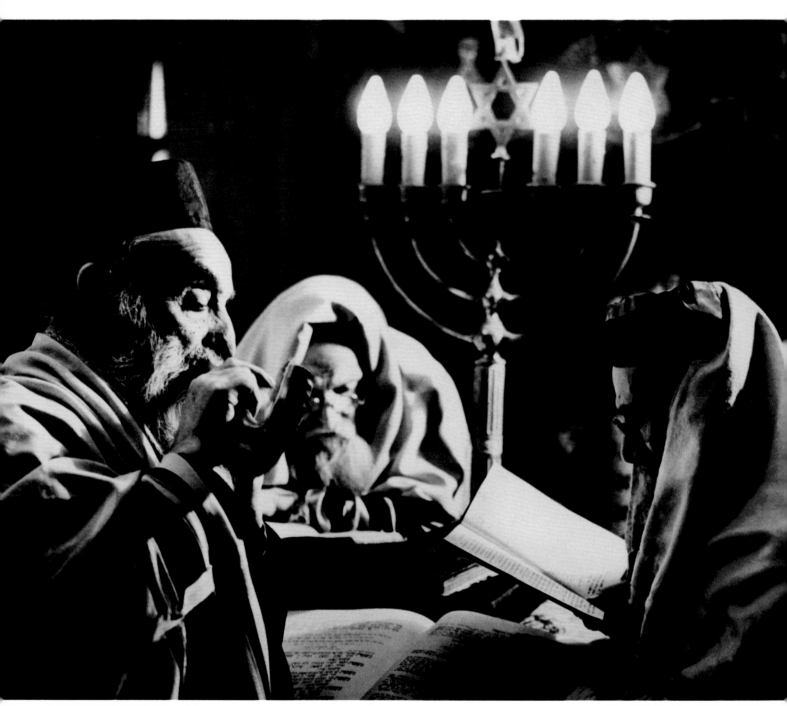

Sounding the call for repentance

OPPOSITE, Studying Torah in memory of the dead

OVERLEAF, The shofar lifts up prayer — to God, circa 1934

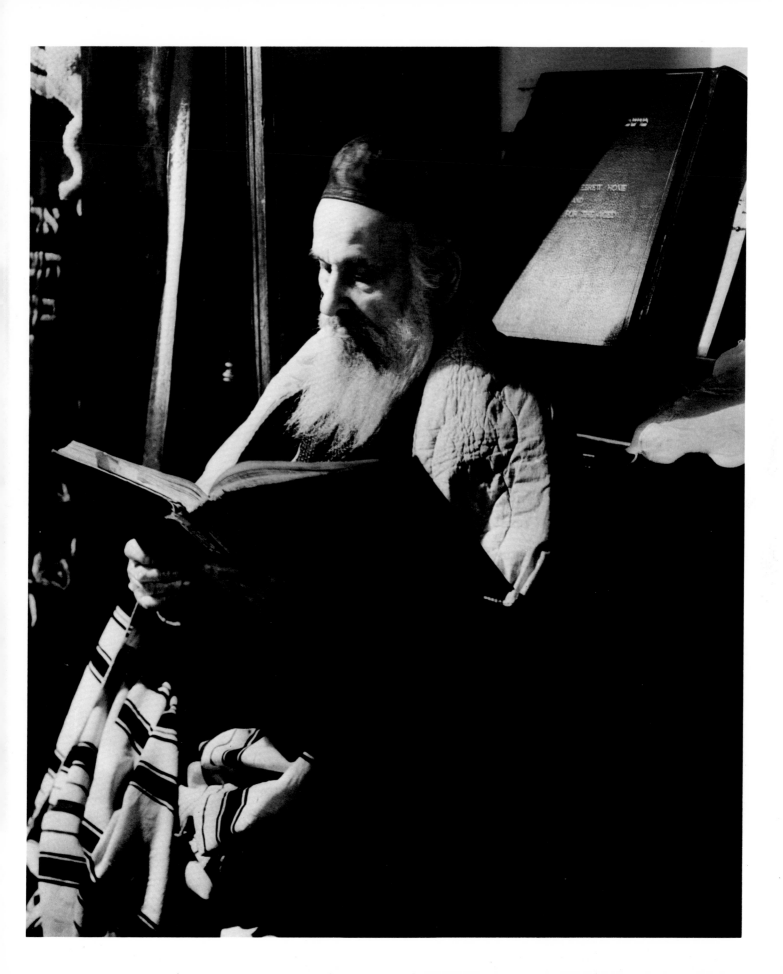

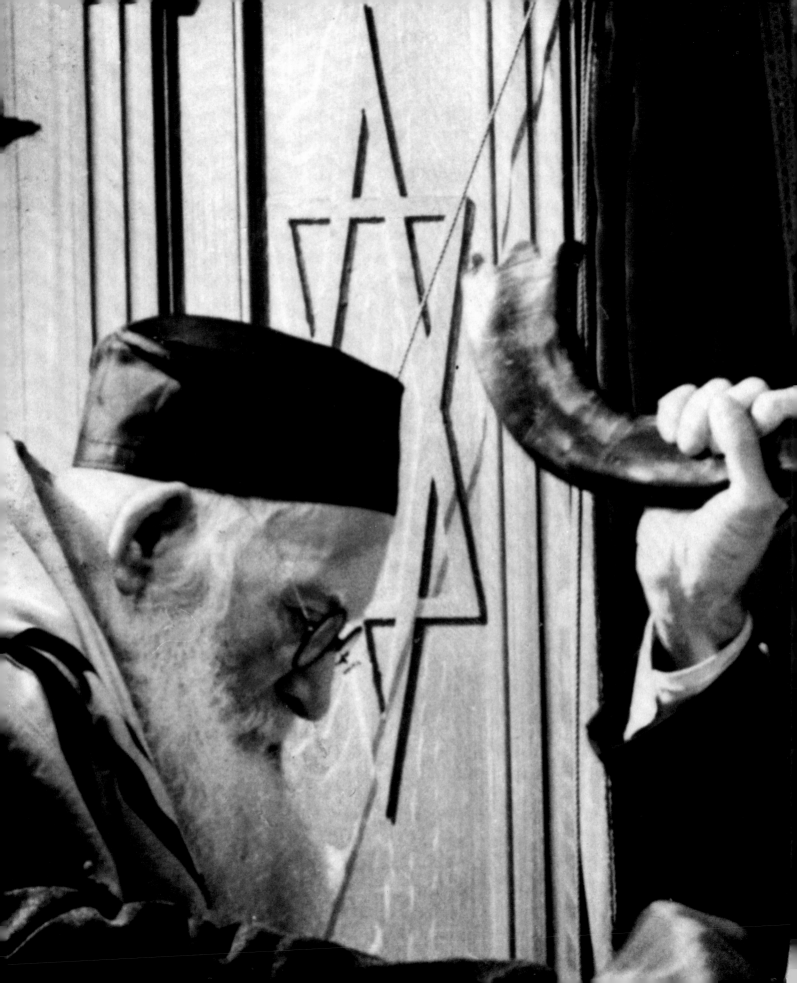

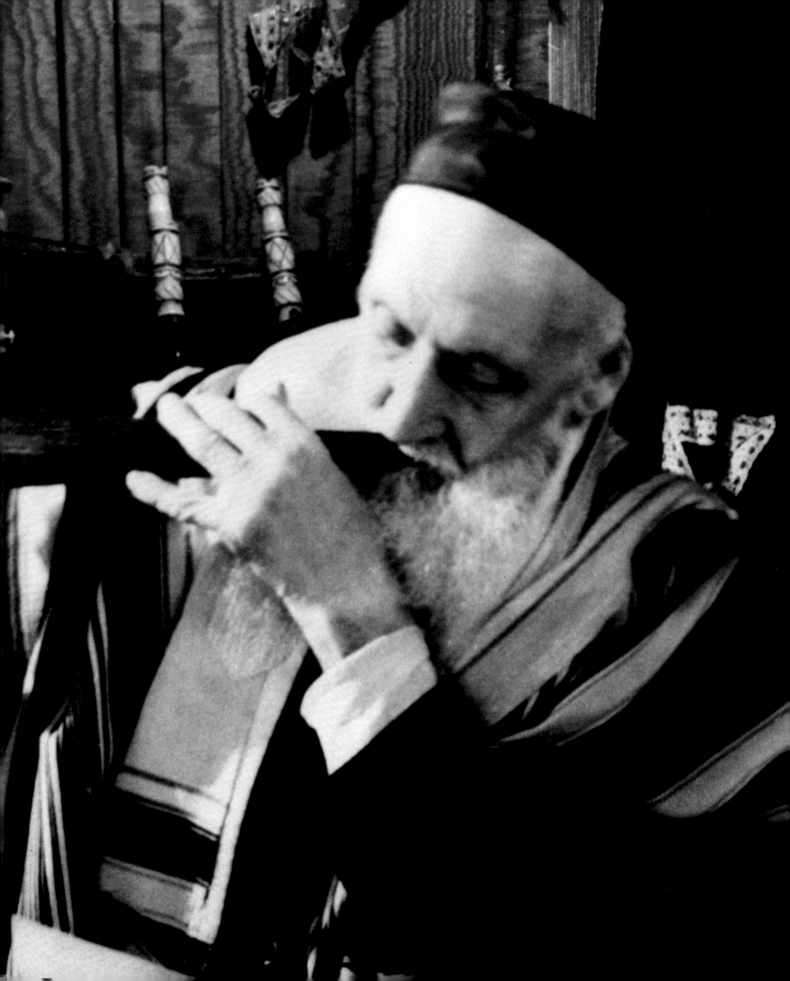

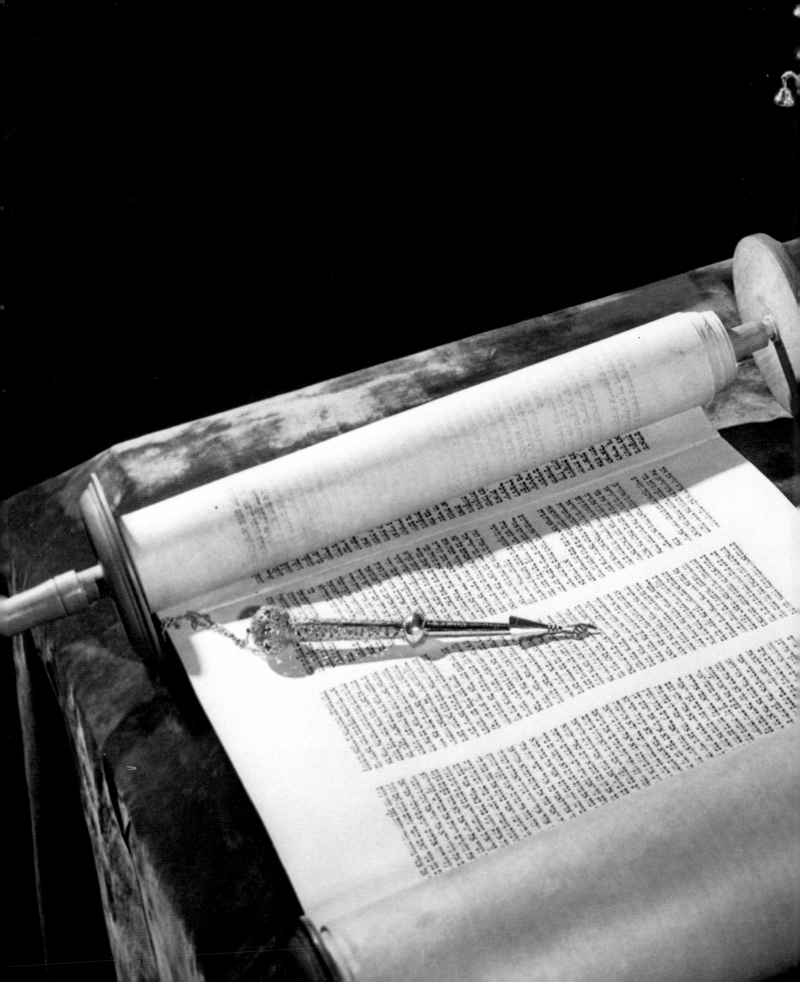

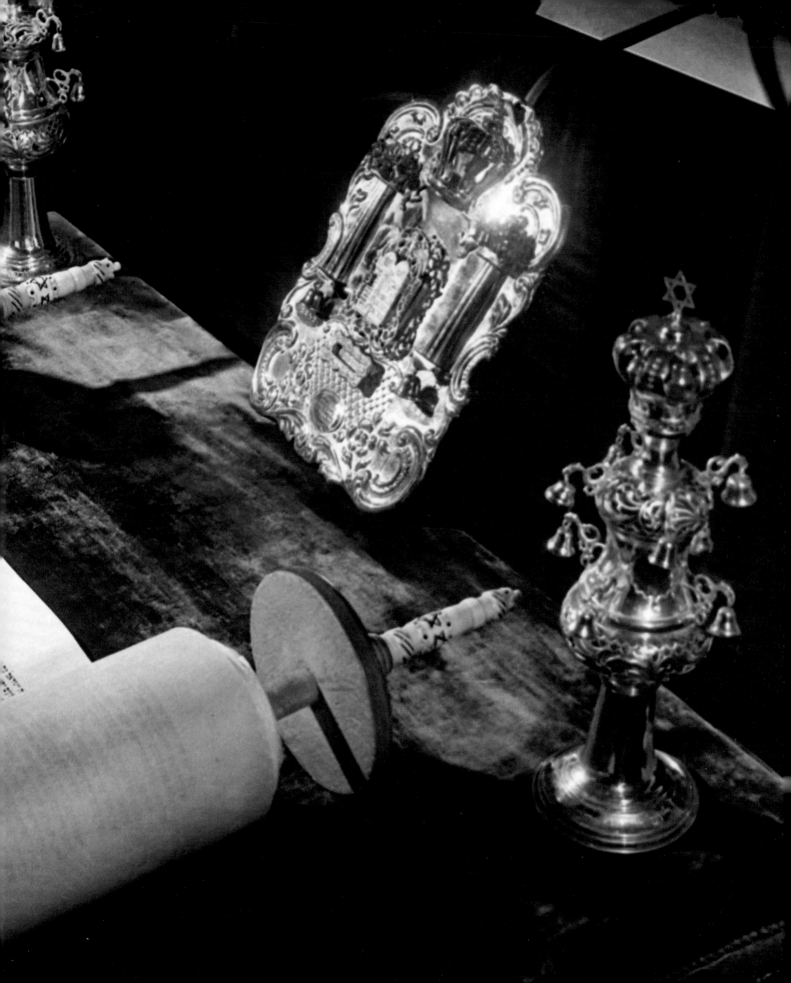

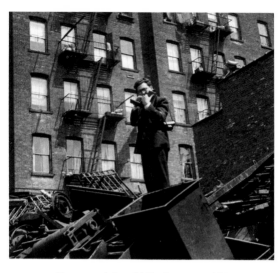

Portrait of Arnold Eagle, circa 1937

Aperture gratefully acknowledges the generous support of
Rapoport/Metropolitan Printing Corp., the Samuel Bronfman
Foundation, Cornell Capa, the Joe and Emily Lowe Foundation,
and Morton Landowne.

Library of Congress Catalog Card Number: 91-76529
ISBN: 0-89381-499-7

The staff at Aperture for *At Home Only With God* is:

Michael E. Hoffman, Executive Director
Andrew Wilkes, Editor
Michael Sand, Managing Editor
James Anderson, Martha Lazar, and Eve Morgenstern,
Editorial Work-Scholars
Stevan Baron, Production Director
Sandra Greve, Production Associate

Book and jacket design by Arne Lewis.

Composition by V&M Graphics. Printed by Rapoport/Metropolitan
Printing Corp. Bound by Horowitz Rae Bindery.

Aperture publishes a periodical, books, and portfolios of fine
photography to communicate with serious photographers and creative
people everywhere. A complete catalog is available upon request.
Address: 20 East 23rd Street, New York, New York 10010.

"Hear Our Voice, 1934" is produced in a limited-edition of
twenty-five 16 × 20″ prints and five artist's proofs signed and
numbered by the photographer. This special limited edition is
available from Aperture. A share of the proceeds supports this project
and the ongoing programs of Aperture, a not-for-profit,
educational-charitable organization, a public foundation.

First edition

10 9 8 7 6 5 4 3 2 1